COMIC BOOK MOVIES

QUICK TAKES: MOVIES AND POPULAR CULTURE

Quick Takes: Movies and Popular Culture is a series offering succinct overviews and high-quality writing on cutting-edge themes and issues in film studies. Authors offer both fresh perspectives on new areas of inquiry and original takes on established topics.

SERIES EDITORS:

Gwendolyn Audrey Foster is Willa Cather Professor of English and teaches film studies in the Department of English at the University of Nebraska, Lincoln.

Wheeler Winston Dixon is the James Ryan Endowed Professor of Film Studies and professor of English at the University of Nebraska, Lincoln.

Blair Davis, *Comic Book Movies*
Steven Gerrard, *The Modern British Horror Film*
Barry Keith Grant, *Monster Cinema*
Daniel Herbert, *Film Remakes and Franchises*
Ian Olney, *Zombie Cinema*
Valérie K. Orlando, *New African Cinema*
Steven Shaviro, *Digital Music Videos*
David Sterritt, *Rock 'n' Roll Movies*
John Wills, *Disney Culture*

Comic Book Movies

BLAIR DAVIS

RUTGERS UNIVERSITY PRESS

New Brunswick, Camden, and Newark, New Jersey, and London

Library of Congress Cataloging-in-Publication Data
Names: Davis, Blair, 1975– author.
Title: Comic book movies / Blair Davis.
Description: New Brunswick : Rutgers University Press, 2018. |
Series: Quick takes: movies and popular culture | Includes
filmography. | Includes bibliographical references and index.
Identifiers: LCCN 2017053303 (print) |
LCCN 2018000138 (ebook) |
ISBN 9780813588780 (epub) | ISBN 9780813588797 (web pdf) |
ISBN 9780813590097 (cloth : alk. paper) |
ISBN 9780813588773 (pbk. : alk. paper)
Subjects: LCSH: Superhero films—History and criticism. |
Comic strip characters in motion pictures.
Classification: LCC PN1995.9.S76 (ebook) |
LCC PN1995.9.S76 D38 2018 (print) | DDC 791.43/652—dc23
LC record available at https://lccn.loc.gov/2017053303

A British Cataloging-in-Publication record for this book is
available from the British Library.

∞ The paper used in this publication meets the requirements of
the American National Standard for Information Sciences—
Permanence of Paper for Printed Library Materials,
ANSI Z39.48-1992.

www.rutgersuniversitypress.org

Manufactured in the United States of America

CONTENTS

COMIC BOOK MOVIES

INTRODUCTION

I've loved comics for as long as I can remember. Same thing with movies. So it's a safe bet that I've seen nearly every film ever based on a comic book, although not all of them have been memorable. Comic books, as we know the publication format today, have been around since the mid-1930s. Comic book movies soon followed, with audiences of that era just as eager to see their favorite characters leap from page to screen as we are today. Today they account for some of the highest-grossing films of all time, even if many film critics still eye them with suspicion.

On the whole, I like comic book movies and still gladly pay money to see them (with some exceptions: most *Teenage Mutant Ninja Turtle* films, because I'm not twelve anymore; more than one *Superman* sequel; *Catwoman* [2004]; nearly half of all the *X-Men* films ever made; any *Fantastic Four* film except the one produced by Roger Corman; *Batman and Robin* [1997]). Like any relationship, my enjoyment of films adapted from comics has had its ups and downs. The thrill of newness gives way to creeping routine but is punctuated by bursts of

reinvigoration. For every uninspired *X-Men* entry I've sat through, there's been a film like *Deadpool* (2016) that's spiced things up. For every tedious sequel like *The Amazing Spider-Man 2* (2014), there's been a superior one like *Spider-Man 2* (2004), proving that not all franchise follow-ups are empty cash grabs.

Even if I haven't enjoyed a given film, I've still savored—albeit briefly—how a familiar character is transported to the cinema in the form of an actor, prosthetic makeup job, or digital effect. The act of seeing a character who was static on the page of a comic but now moves, jumps, and fights on-screen has its own visceral charms no matter how poor the overall film is. I enjoy seeing how comics characters get adapted into movies, even if I don't always admire the actual movies themselves. Even the unmemorable ones still have at least one moment worth watching—the instance in which we first see a print character in motion on the screen instead of the motionless pages of a comic. It's at that moment when we readily bring our experiences with one medium to another, eager to see how the filmmakers translate hand-drawn images into cinematic ones. We understand that these new images can't look exactly the same as the ones we already know, just as a child never looks exactly like a parent. The offspring retains qualities of its source yet remains unique. As viewers, that moment in which we decipher

which elements remain the same and which do not is a chief thrill of adaptations.

Comic book movies emerged as a major Hollywood genre by the early 2000s, yet their long history dates back to the early 1940s. Comic *strip* movies go back even further, as audiences have always craved film versions of their favorite comics characters: hundreds of silent shorts and animated films based on comic strips were produced in the dawn of the twentieth century, like *The Katzenjammer Kids, Happy Hooligan, Buster Brown, Dream of the Rarebit Fiend, Mutt and Jeff, Krazy Kat,* and many others. Feature films followed, with silent efforts like *Tillie the Toiler* (1927) and *Harold Teen* (1928) giving way to such sound films as *Skippy* (1931), *Little Orphan Annie* (1932), and *Blondie* (1938). Animated adaptations continued in the sound era, with numerous shorts based on *Popeye, L'il Abner,* and *Superman.* Cliffhanger serials also proved popular, with films based on newspaper characters and comic book heroes alike continuing well into the early 1950s—at which point television took over as the dominant destination for adapting comics characters for the next two decades.

In 1978, Christopher Reeve donned an iconic red cape for Richard Donner's *Superman,* giving the world its first blockbuster comic book movie. The 1980s and 1990s saw numerous comics characters—but not always the most

well-known ones—make their screen debut in *Swamp Thing* (1982), *Howard the Duck* (1986), *The Rocketeer* (1992), *Blade* (1998), and *Mystery Men* (1999). A few film series were born in this era, like *Batman* (1989), *Teenage Mutant Ninja Turtles* (1990), and *The Crow* (1994), but each fizzled as they reached their final sequels. With the campy tone of *Batman and Robin* failing at the box office, Hollywood wondered whether bigger was better or whether superheroes were best suited to lower-budget entries like New World Pictures' *The Punisher* (1989) and 21st Century Film Co.'s *Captain America* (1990). But as the new millennium began, the success of *X-Men* (2000) and *Spider-Man* (2002) proved that the most popular heroes could support big-budget treatments if taken seriously by skilled directors like Brian Singer and Sam Raimi.

A flood of comic book movies soon followed, some very good (*American Splendor* [2003], *Spider-Man 2*, *Batman Begins* [2005]), some very bad (*The League of Extraordinary Gentlemen* [2003], *Catwoman*), and one with an ugly reputation that I will argue as highly underrated (*Hulk* [2003]). Still more are merely watchable in small doses—being occasionally pleasurable in how they bring familiar characters to the screen for the first time (*Daredevil* [2003], *Constantine* [2005], *Ghost Rider* [2007], *Green Lantern* [2011]) but ultimately forgettable.

But the resounding success of comic book movies in recent years stems from more than just the delight in seeing characters jump from panel to screen. There are cultural and technological reasons for their staying power. In many ways, the boom in cinematic superheroes now plays the same role that the western genre did in past decades, as a forum for exploring American identity and politics using themes of heroism, militarism, and cultural transformation. Liam Burke notes in *The Comic Book Film Adaptation* that "just as the western protagonist proved readily interchangeable with the superhero in comics, the comic book hero now fills a role once held by the cowboy on cinema screens," with each reflecting "the ideological precepts that underlie American mythology" (94).

While the traumatic events of 9/11 are often seen as a catalyst for the comic book film's popularity, advancements in special effects are equally responsible for the upsurge. Superpowers have been historically difficult to re-create on-screen, but the digital effects now give audiences new, spectacular images of flight, strength, and bodily transformation alongside social and political ideas in films like *The Dark Knight* (2008), *Iron Man* (2008), *X-Men: First Class* (2011), and *Captain America: Civil War* (2016). In using extraordinary characters as allegories for real-world issues, comic book movies have achieved

enduring acclaim from critics, comics fans, and movie-goers alike.

The four chapters that follow look at comic book movies though perspectives of genre, myth, politics, and style. Chapter 1 explores why it is actually a misnomer to use the label "comic book movie," since comics are a medium made up of a wide range of different genres. Using film genre theory, I trace the narrative, thematic, and visual patterns of what the public, critics, and producers routinely call comic book movies, while reconciling how this label gets applied to superhero films along with sci-fi, war, crime, and horror movies. I also look at movies based on comics with cult followings and those offering personal stories instead of bombastic battles. Underground comics and independent titles inspired films like *Fritz the Cat* (1972), *Heavy Metal* (1981), *Crumb* (1994), *Ghost World* (2001), *Art School Confidential* (2006), and *Scott Pilgrim vs. the World* (2010). Adaptations of autobiographical comics like *American Splendor* and *Persepolis* (2007) have also found success, proving that comic book movies aren't all about superheroes.

Chapter 2 details the role of myth, from how actual mythic figures are embodied in *Adventures of Captain Marvel* (1941), *Thor* (2011), and *Wonder Woman* (2017) to how films like *Batman v. Superman: Dawn of Justice* (2016) construct (and question) superheroes as modern-day

gods. Explorations of heroism and morality continue into chapter 3, which looks at the politics of comic book movies. Superman and Batman both fought Axis spies on-screen during World War II, while images of war and homeland security remain prevalent in films like *300* (2007), *Iron Man*, *The Losers* (2010), *Captain America: The Winter Soldier* (2014), and *Captain America: Civil War*. At the same time, the dystopian and anarchist themes in *The Dark Knight*, *Dredd* (2012), *X-Men: Days of Future Past* (2014), *X-Men: Apocalypse* (2016), and *Suicide Squad* (2016) reflect the divisive nature of modern US politics and the ever-present threat of global terrorism.

Chapter 4 moves away from social issues to examine the role of style in comic book films. From the evolution of special effects and how they represent human (and in-human) bodies to how digital cinema can make impossible feats appear realistic, comic book movies make us believe that men and women can fly and that great power can result from either accident or fate. Many comic book movies also mimic the formal qualities of comics themselves, re-creating panels, captions, and other devices to emulate their source material. Comic book movies also demonstrate the growing importance of franchises and transmedia storytelling in modern Hollywood: with the Marvel Cinematic Universe in the hands of Disney, and DC Comics' films guided by Warner Bros.

Entertainment / Time Warner, cross-pollination via numerous media platforms grows increasingly important to how studios adapt comic books.

Comic book movies became a top Hollywood genre by appealing to niche fandoms and mass audiences alike, and they will continue to play a central role in popular culture for years to come. The ideas that follow are meant to be challenged, discussed, disagreed with, expanded on, and/or reinterpreted. They sum up my understanding of how these films function in modern cinema. They might not always match yours, nor will they necessarily reflect future trends in how comics get adapted into movies. I sympathize with Orson Welles when he said in *Citizen Kane*, "Charles Foster Kane is a scoundrel. His paper should be run out of town. A committee should be formed to boycott him. You may, if you can form such a committee, put me down for a contribution of one thousand dollars." Any scholar unprepared to have his or her ideas run out of town should seek shelter elsewhere.

I've often written historical analyses of the subject matter at hand in my earlier books, but this time it's more about theoretical ideas and current patterns (which are constantly changing). Historical facts often are what they are. Stuff happens. But theories and ideas, by their very nature, should invite debate. My hope is that at least some of these ideas resonate with you. As the legendary

Canadian media theorist Marshall McLuhan (who was fond of using metaphors and aphorisms to explore ideas, through what he called "probes") would say, "if you don't like those ideas, I have others" (Federman).

It's tempting to overanalyze these films, and you may well insist that I'm doing exactly that at times as I delve into the cinematic, mythic, cultural, and political readings of characters and stories that typically offer escapist pleasures at their very core. I too often read comics to escape the world and the horrible, horrible people in it. I like a good story. I like a nice fight scene. I like it when stuff explodes loudly and messily on-screen. So I too have cringed at overanalyzed treatises of pop-culture phenomena.

But in thinking through the recent surge of films starring my favorite comics characters, I keep finding it hard *not* to draw parallels across the franchises, reboots, and sequels. These films *do* offer compelling allegories about changes we are now in the midst of, such as changes concerning how technology affects our bodies (both literally, as far as what we add onto, and into, ourselves through surgical or consumer activity, and with regard to our mental understanding of the body in relation to gender and personal identity). They also offer dystopian tales reflecting the dark turn in modern politics, both in the United States and in many other parts of the world.

While comic book movies offer intriguing ideas and metaphors along with their spectacular images, far more people watch the adaptations than read actual comics. I'm not quite sure whether I fell in love with comics or movies first, but I know that I still adore comics more than the films adapted from them. The comics industry is more than just a testing ground for stories and characters to be brought to other media and milked for their merchandizing potential (despite how adorable my son looks while fast asleep on his *Avengers* sheets, hugging his stuffed Spidey toy). Comics are a sophisticated medium used to tell powerful stories, conduct aesthetic experiments, and explore cultural identities in unique ways. Comic book movies, though increasingly subject to the franchise-driven logic of Hollywood, are starting to do the same.

1

GENRE

Despite how widespread the "comic book movie" label has become, it is perhaps the most problematic term to ever describe a film genre. The names we give genres shape our expectations as an audience about what a certain film might offer. The western implies a certain time and place (the Old West). Science fiction suggests stories rooted in scientific exploration. The romance promises tales of love, while horror films hint at frightful situations and menacing characters. Comic book movies, however, imply only that their narratives and characters originated in comic books. The term tells us nothing about the common settings of the films or their themes, characters, or images. We might assume comic book films feature superheroes, but this is not guaranteed; numerous films without any hint of caped crusaders or superpowers still get called "comic book movies" by fans, critics, and producers. Instead of giving us a real sense of what the movie will be about, the label only informs us about the source

material. We don't speak of *To Kill a Mockingbird* (1962), *The Godfather* (1973), or *No Country for Old Men* (2007) as "novel movies" or *His Girl Friday* (1940), *Dial M For Murder* (1954), or *A Few Good Men* (1992) as "play movies," because such terms tell us little about the particulars of these films.

Using an entire medium to describe a certain group of films is an exercise in futility, because a medium itself is not a genre. A medium like comics (or novels or plays) is a unique form of communication used to tell stories in any given genre. Calling something a comic book movie only tells us that the characters in a film have been adapted from another medium. While some people might call *His Girl Friday* a newspaper movie or *Radio Days* a radio movie, such terms describe the specific settings and professions of the main characters in ways the "comic book" label does not. We wouldn't refer to the Transformers or Lego film franchises simply as "toy movies," because the term tells us nothing about the types of characters, settings, or story lines we might expect to find.

Describing a group of films as a certain genre is a categorical effort to include particular titles because of similarity and exclude others for being different. Films like *Stagecoach* (1939), *The Searchers* (1956), *The Good, the Bad, and the Ugly* (1966), *Unforgiven* (1992), and *The Assassination of Jesse James* (2007) are called westerns because

they are all set in the mid- to late 1800s American West or Midwest, feature cowboys and outlaws who ride horses and shoot pistols, and explore themes of violence, masculinity, and societal belonging. Similarly, we call *Flash Gordon* (1936), *The Day the Earth Stood Still* (1951), *Star Wars* (1977), and *District 9* (2009) science fiction films because they involve travel to (or from) other worlds, feature advanced technologies and/or weaponry, and portray themes of social conflict, otherness, and heroism.

The same commonalities are more difficult to find when looking at the titles that make up the genre of comic book movies. How many narrative or character similarities exist between *Ant-Man* (2015) and *American Splendor*? Between *Green Lantern* and *Ghost World*? There is little comparison between the gladiators of *300* and the vampires of *30 Days of Night* (2007) beyond mutual bloodshed, just as *Sin City* (2005) and *Superman Returns* (2006) sit far apart in their thematic approaches to identity and morality. But all of these films commonly get grouped together by audiences, journalists, and websites simply because they stem from the same type of source material: comics.

The film scholar Heather Dubrow describes how each genre "functions much like a code of behavior" in cinema (2), while the theorist Torben Grodal sees "a set of dominant features" for each individual genre, "which shapes

the overall viewer-expectations and the correlated emotional response" (163). These "dominant features" include the kinds of character types, settings, props, themes, and narrative patterns that recur among certain films, unifying them within a single genre. This repetition of common elements across multiple films establishes the code of behavior that Dubrow describes, in which filmmakers reiterate or build on the patterns established in earlier films.

Audiences also participate in this code, which shapes their expectations for the type of story, characters, and imagery a particular genre film presents. The "emotional response" mentioned by Grodal is typically the comfort found by most viewers in familiar, reoccurring patterns or in how established tropes and images are reinterpreted in new ways.

On the whole, comic book movies don't adhere to these definitions as neatly as other film genres do. Taking props as one example, both the western and science fiction genres are known for their distinctive weaponry. The six-shooter that Ethan Edwards wields in *The Searchers* would be out of place in *Star Wars*, just as Han Solo's laser blaster would be equally ridiculous in John Wayne's hands. But comic book movies offer a variety of handguns in *Road to Perdition* (2002), *Sin City*, and *RED* (2010), blasters and laser cannons in *Men in Black* (1997), *Dredd*, and *Guardians of the Galaxy* (2014), not to

mention devices like web shooters (*The Amazing Spider-Man* [2012]), jetpacks and flying suits (*The Rocketeer; Iron Man*), Wolverine's claws in the *X-Men* franchise, and the cosmic Tesseract of the *Avengers* films. Most such props would appear drastically out of place in a different film. If the gladiators of *300* or the criminals in *Kingsman: The Secret Service* (2015) suddenly sported claws, wings, or other such biological extensions, the result would appear ludicrous. Such amalgamation was tried in *Cowboys and Aliens* (2011), though it was largely dismissed by both audiences and critics, who found the anachronisms unsatisfying and unimaginative.

Just as we can't necessarily expect to find close similarities between any two films based on novels, expecting commonalities across different comic book movies is equally problematic. We can't even use superpowers to find common ground among comic book movies, given films like *300*, *Sin City*, *RED*, *Kingsman: The Secret Service*, *Judge Dredd* (1995), *Creepshow* (1982), and *Tales from the Crypt* (1972) and their sequels or remakes. Supernatural-driven films like *The Crow*, *Blade*, *Hellboy* (2004), and *Constantine* also spawned sequels and/or television series despite their protagonists not being superpowered in the traditional sense.

Even if the term remains difficult to reconcile according to the theory behind it, the "comic book movie"

moniker seems well entrenched. Some terms just become hard to shake, much like the way the "graphic novel" moniker is a contentious one among many comics fans and scholars (since it gets applied to both original works telling a unified story and reprint collections of previously published, serialized comic books). The "comic book movie" label increasingly appeared in the early 2000s as the success of the *X-Men* and *Spider-Man* franchises led to a wave of other films based on comics. Film critics and industry reporters and began using the term regularly (and often casually) by 2004, with *USA Today* calling *The Punisher* (2004) "Hollywood's latest comic book movie" (Keck), and the BBC describing *Catwoman* as "the latest big-budget comic book movie" ("Catwoman Movie Mauled").

Still, an air of condescension circled about the term, with a *New York Times* review of *Batman Begins* pondering, "It's amazing what an excellent cast, a solid screenplay and a regard for the source material can do for a comic book movie" (Dargis, "Dark"). The *San Francisco Gate* suggested that with *Spider-Man 2*, director Sam Raimi "has succeeded in making what Ang Lee tried to make with 'Hulk,' a thinking person's comic-book movie. Raimi and his writers succeed by realizing that the thinking has to be comic-book thinking and the crises have to be comic-book crises. This is not 'Hamlet'" (LaSalle).

Despite the prevalence of comic book movies more than a decade later, they still get described in the same dismissive terms. A *Hollywood Reporter* review of *Doctor Strange* (2016) notes that the presence of respected actors like Benedict Cumberbatch, Tilda Swinton, and Chiwetel Ejiofor makes the film seem classier than it should given the source material: "Do comics-derived films really require thespians of this caliber when the effects and genre elements are their raisons d'etre? Well, no, but they unquestionably class up the joint by injecting wit, elocution, faces with character and commanding presence into material that needs all the elevation it can get to not seem entirely juvenile" (McCarthy).

Even after dominating the box office for over a decade, comic book movies—like comics themselves—are still regarded with dubious eyes by those who question their merit. But what many conceive of as a single genre is in fact composed of films representing a wide range of other genres, from action films to westerns, supernatural films, war movies, and science fiction. Their current popularity has been sustained in part because of the ways in which comic book movies combine elements of different genres together. Comic book movies are not a single genre but a hybrid of many genres, with new permutations like *Guardians of the Galaxy*, *Deadpool*, and *Doctor Strange* proving these adaptations' enduring appeal.

GENRE CYCLES AND SUBGENRES

All film genres rise and fade in popularity. Some endure for decades, like the western, while others enjoy relatively brief phases lasting only a few years. When the screenwriter David Goyer was asked in 2004 whether he thought comic book movies might soon decline, he replied, "I don't think so. I think they will ebb and flow like any other genre. . . . I think we've got a good five more years of a lot of comic book movies coming out [and] being massive hits. And I think it'll ebb for a while, and then it will come back. I think it'll be a genre that will stay" (Otto). While comic book movies have dominated box offices well beyond the five-year window Goyer mentions, the ebb and flow described here relates to genre cycles, which are "relatively brief but intense periods of production of a similar group of genre movies" (Grant 36).

One example of these cycles is the horror genre, which saw an upsurge in monster movies after *Dracula*'s success in 1931. More horror films followed, including *Frankenstein* (1931), *The Mummy* (1932), *Island of Lost Souls* (1932), *The Invisible Man* (1933), *Bride of Frankenstein* (1935), and *Dracula's Daughter* (1935). Similarly, *X-Men* and *Spider-Man* led to a wave of comic book adaptations, such as *X2: X-Men United* (2003), *Daredevil, Hulk, Catwoman, Hellboy,* and *The Punisher* (2004).

The horror genre also saw a cycle of films in the 1930s based on larger themes of the supernatural beyond just monsters, such as *White Zombie* (1932), *Supernatural* (1933), *Black Moon* (1934), *The Black Cat* (1934), *Mad Love* (1935), and *The Walking Dead* (1936). Both cycles died out in 1936, but a new cycle of films featuring monsters and mad scientists began in 1939 with *Son of Frankenstein* (1939), followed by *The Return of Dr. X* (1939), *The Mummy's Hand* (1940), *The Invisible Man Returns* (1940), *The Wolf Man* (1941), *The Ghost of Frankenstein* (1942), *The Mummy's Tomb* (1942), *The Return of the Vampire* (1943), *Son of Dracula* (1943), *House of Frankenstein* (1944), and *The Mummy's Curse* (1944). At the same time, another supernaturally themed cycle emerged emphasizing psychologically based horror rather than creatures on the loose, including *Curse of the Cat People* (1943), *I Walked with a Zombie* (1943), *The Uninvited* (1944), *Weird Woman* (1944), *Isle of the Dead* (1945), and *The Picture of Dorian Gray* (1945). Similarly, the early 2000s surge in superheroes was balanced by films adapted from comics of other genres, such as *From Hell* (2001), *Ghost World*, *Road to Perdition*, *Bulletproof Monk* (2003), *American Splendor*, and *League of Extraordinary Gentlemen*.

Once again, both cycles of horror films ended together in 1946 as the genre faded in popularity overall. Horror movies returned in the 1950s with various cycles

emphasizing teenage protagonists (such as American International Pictures' *I Was a Teenage Werewolf* [1957]), gothic monsters (including Hammer Films' *The Curse of Frankenstein* [1958]), and atomic-era creature-features (*Them!* [1954], *Tarantula* [1955]). Later cycles featured demonic possession (*The Exorcist* [1973], *Abby* [1974], *The Omen* [1975]), psychopathic killers (*Halloween* [1978], *Friday the 13th* [1980], *Prom Night* [1980]), and literary adaptations (*Bram Stoker's Dracula* [1992], *Mary Shelley's Frankenstein* [1994], *The Island of Dr. Moreau* [1996]). Since these genre cycles can be organized around a certain theme, premise, character type, and so on, most of them were unlike any other yet remained united under the common banner of the horror genre. As the popularity of a particular cycle faded, the genre either reinvented itself or else disappeared for a time; the same is true of most film genres, which ebb and flow according to audience demands.

The endurance of comic book cinema may depend on producers and audiences understanding how different cycles can occur simultaneously at any given time. *Batman*'s success in 1989 quickly led to other films based on comic books and strips, such as *Dick Tracy* (1990), *Teenage Mutant Ninja Turtles* (1990), *Teenage Mutant Ninja Turtles II: The Secret of the Ooze* (1991), *The Addams Family*

(1991), and *The Rocketeer*. The often family-friendly tone of that cycle continued with *Addams Family Values* (1993), *Teenage Mutant Ninja Turtles III* (1993), *Dennis the Menace* (1993), *The Mask* (1994), *Richie Rich* (1994), and *Casper* (1995).

But a new cycle also emerged, taking after the darker mood of *Batman Returns* (1992). The violent imagery of films like *The Crow*, *Timecop* (1994), *Judge Dredd*, and *Tales from the Crypt: Demon Knight* (1995) earned each an R rating. Both cycles ran side by side for a while but stalled toward the end of the decade as the critical and commercial disappointments of *Batman and Robin*, *Spawn* (1997), and *Steel* (1997) saw the genre's presence in Hollywood dwindle.

The late 1990s saw only a few little-known characters adapted for the screen in *Blade* and *Mystery Men*. *Blade* star Wesley Snipes had connected with audiences in action films like *Passenger 57* (1992), *Demolition Man* (1995), and *U.S. Marshals* (1998), while *Mystery Men* starred established comedy actors Ben Stiller, Janeane Garofalo, Paul Reubens, Hank Azaria, Kel Mitchell, and Eddie Izzard. In both cases, *Blade* and *Mystery Men* were marketed not using their source material (which few filmgoers were familiar with) but with the familiar codes and viewer expectations of the action, horror, and comedy genres.

The film historian Rick Altman sees the way in which the film industry and its scholars, critics, and audiences understand genres as the process of "constant category-splitting and category-creating" (18). Genres are not unified collections of narrative and visual patterns applied with unwavering consistency. They continually evolve, often fracturing themselves as they follow new directions or return to older archetypes so that they may be reinterpreted and reinvented. One of the major reasons why comic book movies are so prolific is that they reflect such a wide range of different subgenres. *Blade* is an action-horror film, *Mystery Men* an action-comedy. *Iron Man* and *Captain America: The First Avenger* (2011) each display elements of war films and action movies, while *Thor* has aspects of the fantasy genre.

"Any film (like any text, utterance or representation) can participate in several genres at once. In fact, it is more common than not for a film to do so," says the film scholar Steve Neale (25). While we could rightly call superhero films their own genre, given the recurring emphasis on colorful costumes, secret identities, superhuman abilities, and villainous foes, such films routinely feature elements from other genres like war movies, fantasy, science fiction, and crime films. Understanding the ways in which films adapt comics involves recognizing the different combinations of multiple genres.

"I MAY BE SUPER, BUT I'M NO HERO": ACTION

Since the majority of comic book movies are superhero films, and most superhero films have elements of the action genre (including fight scenes, frantic pursuits, shoot-outs [be they ballistics or superpowered], explosions, and heroic conflicts to prevent world domination from nefarious forces), it is fair to say that the action film is a dominant part of comic book cinema. The film scholar Harvey O'Brien describes the action film genre as "a cinema of crisis and reaction—of attempting to restore agency through force of will" (1). Action films are full "of spectacle, of violence, of acts of will and contest," he says, depicting "the struggle to overcome obstacles" with "heroes [who] are being tested" (3). Spectacle and violence are core elements of most comic book movies, which show us the physical trials of heroes struggling to restore order. Moments of action are regularly emphasized in trailers and marketing efforts, after all, in order to sell these films as sensational blockbusters.

The entire Marvel and DC cinematic universes can be understood as action films, full of conflicts between heroes and villains, superpowered showdowns and explosive encounters. The same is true of the various X-Men and Wolverine movies, which emphasize mutant-on-mutant fight scenes, along with clashes involving swords,

staffs, and nunchuks in the *Teenage Mutant Ninja Turtles* films (1990, 1991, 1993, 2007, 2014, 2016). Gun battles are prominent in *Deadpool*, *RED*, *Sin City*, and *The Punisher* (2004), while *Wanted* (2008) is akin to the "gun-fu" action films of John Woo, in which the firing of bullets becomes a rhythmic, graceful act. Similarly, *Watchmen* (2009) features a slow-motion fight sequence during a prison break, extending what happens within a mere panel in the comic book into more than a minute's worth of screen violence.

Deadpool contains an early action sequence in which the titular antihero plunges off a bridge to attack a group of criminals, crashing through the sunroof of their vehicle on the expressway below. A fight ensues inside the vehicle, with one baddie thrown from the rear of the car only to be dragged while it continues at top speed. Another assailant pulls up alongside on a motorcycle and fires multiple rounds into the speeding car. The passenger door is blown off and goes flying into the motorcycle as a trail of metal quickly litters the freeway. The assailant leaps onto the back of the car, attempting to shoot Deadpool. Cars slam together along the way, and the vehicle careens through the air toward another attacker on motorcycle.

As the car spins, Deadpool sticks his arm out of the sunroof and grabs the rider, who is then decapitated by a flying bike chain. The spiraling vehicle crashes into the blacktop, but not before one of the villains is thrown

from the car into the highway sign above (resulting in a bloody mess). Aside from the advantages that Deadpool's enhanced strength gives him in fighting his opponents, the entire sequence would not feel out of place in a *Die Hard* or *Fast and the Furious* film. Highway chases feature prominently in action films like *Bad Boys 2* (2003), *The Island* (2005), *Transformers: Dark of the Moon* (2011), *A Good Day to Die Hard* (2013), *Fast and Furious 6* (2013), and *Mad Max: Fury Road* (2015), with *Deadpool*'s gunplay and car crashes embodying several tropes of the action genre.

As Deadpool himself tells his film's audience (breaking the fourth wall) while the action escalates and the gruesome death toll mounts, "You're probably thinking, 'My boyfriend said this was a superhero movie, but that guy in the suit just turned that other guy into a fucking kebab!' Well, I may be super, but I'm no hero." As he kills his enemies with both gruesomeness and glee (all while gladly telling us about it directly), we soon learn that Deadpool doesn't adhere to the same code of ethics guiding such upstanding superheroes as Superman and Captain America. In turn, Deadpool joins the ranks of other action movie antiheroes like Max Rockatansky (*Mad Max* [1979]), John Rambo (*First Blood* [1982]), and Chev Chelios (*The Transporter* [2002]), whose films revolve around revenge and rising body counts. As sequels and imitators

follow in the wake of *Deadpool*'s enormous box-office success, the action genre will continue to be well represented within comic book movies in the years ahead.

"PEACE MEANS HAVING A BIGGER STICK THAN THE OTHER GUY": WAR

Images of war are a regular part of comic book movies. It should not be surprising then that comic book movies have flourished most in times of war. As the United States entered World War II in 1941, comic book movies were just beginning to reach theaters with the first animated *Superman* short and the first serial based on a comic book, *Adventures of Captain Marvel*. A *Batman* serial followed in 1943, in which the caped crusaders battled the Japanese saboteur Dr. Daka's efforts to mind-control top American scientists and steal military secrets. Many serials of this era featured Axis spies as a way of using World War II to create timely conflicts and make their audience more invested in the villain's defeat. War-era audiences hissed at Dr. Daka as he spouted such lines as, "The League of the New Order of [Japanese Emperor] Hirohito, Heavenly Ruler and Prince of the Rising Sun, marches on, and nothing will ever stop it. You might just as well try to stop the tides, the winds." Superman also battled Japanese spies in the unfortunately named 1942 animated short

Japoteurs, while the lesser-known character Spy Smasher battled Nazis in an eponymous serial that same year. The 1952 serial *Blackhawk*, based on the Quality Comics series of the same name, depicts a band of former World War II pilots who continue their fight against foreign espionage.

War also pervades much of modern comic book cinema, as the Afghanistan and Iraq wars parallel the box-office dominance of comic book movies throughout the early twenty-first century. *300* tells the story of a Spartan army's efforts against King Xerxes in the Battle of Thermopylae in 480 BC during the Persian Wars. *Wonder Woman* is set during World War I, with the Amazonian princess Diana fighting side by side with British soldiers in the trenches and across enemy lines. *Captain America: The First Avenger* is primarily set during World War II, recounting its hero's origins as he is at first turned away from a recruiting station before being transformed into a super soldier and battling the Red Skull's Nazi forces. *Hulk* and *The Incredible Hulk* (2008) both pit the US Army against the green goliath, who sends one tank flying through the desert like a Frisbee in the first film and destroys several army vehicles and a helicopter in the second.

X-Men: First Class revolves around 1960s Cold War efforts between the United States and the Soviet Union. A fleet of battleships is sent in against the mutants and

a barrage of missiles launched, which Magneto stops in their tracks using his magnetic abilities. The film's naval imagery continues when he also pulls a submarine out of the water using his powers. The role played by S.H.I.E.L.D. in *The Avengers* (2012) and *Avengers: Age of Ultron* (2015), with its Helicarrier, fighter planes, and various military-grade weapons, also draws heavily on the war genre (the character Nick Fury originated in the 1960s war comic book *Sgt. Fury and His Howling Commandos*).

Iron Man begins with Tony Stark riding in a military convoy in Afghanistan to demonstrate a new missile he has developed. When a reporter questions his company's use of military funding, Stark replies, "My old man had a philosophy: peace means having a bigger stick than the other guy." The reporter shoots back, "That's a great line coming from the guy selling the sticks." When Stark's convoy is attacked by a terrorist group, he is captured and forced to build a missile for them. Instead, Stark develops the basics of the technology that will power his Iron Man suit, using a prototype to escape. As Iron Man, Stark uses his new suit to liberate a small Afghanistan village, later facing attack by US fighter jets. Such scenes, along with characters like War Machine (Stark's friend Lieutenant Colonel James Rhodes), closely align the *Iron Man* films with the imagery of the war genre. With war being so central to the comic book origins of characters like Wonder

Woman, Captain America, Nick Fury, and Iron Man, the ways in which comic book movies have included various tropes of the war genre have been a natural fit in how these heroes are brought to the screen.

"STRANGE VISITOR FROM ANOTHER PLANET": SCIENCE FICTION

American science fiction cinema emerged around the same time as comic books began hitting newsstands in the mid-1930s. Among the first sci-fi heroes brought to the screen were Flash Gordon and Buck Rogers, adapted from their newspaper-strip adventures into cliffhanger serials. While science fiction cinema largely disappeared throughout most of the 1940s, comic book superheroes were soon anointed as serial stars given the overall affinity between comics and cliffhangers. But as comic book movies progressed, sci-fi elements often remained.

A repeating theme is that of an organization dedicated to defending against alien threats, be they on Earth or across distant galaxies. Based on a 1990 title from Aircel Comics,[1] *Men in Black* tells the story of a secret agency dedicated to protecting the planet from extraterrestrial conflict while monitoring an array of aliens who have sought refuge on Earth. In both the original film and its sequels (2002, 2012), the narrative appeal lies in the

audience's discovery of the agency, its mission, and its role in defending Earth from malicious aliens (all without the public's knowledge, thanks to a memory-erasing device). In keeping with the science fiction genre's emphasis on other-world encounters, the story's scope is much larger than the urban conflicts frequently seen in superhero films like *Batman, Daredevil, Kick-Ass* (2010), and *Deadpool*.

Similarly, *Green Lantern* depicts test pilot Hal Jordan's inauguration into the Green Lantern Corps, an intergalactic peacekeeping force whose members wield power rings allowing them to fly through space and conjure energy fields that can take any shape imaginable. Much as audiences enjoyed Will Smith's training sessions and his shocked reactions to the aliens living among us in *Men in Black*, so too do the best moments in *Green Lantern* feature Ryan Reynolds's first encounters with the Corps' diverse alien species on the planet Oa before being trained in using his ring. While the film failed to generate a sequel, Warner Brothers has announced plans for a Green Lantern Corps movie in hopes of extending the narrative scope of its DC cinematic universe to include cosmic settings and conflicts.

Marvel successfully applied the same strategy with *Guardians of the Galaxy*, which became the highest-grossing film domestically in 2014. The film is decidedly sci-fi rather than superhero driven, given how the abilities

of each alien are natural to its species, much like in the *Star Trek* or *Star Wars* movies. The powers on display are only "super" insofar as the ability of human beings to walk upright might seem superior to four-legged animals. Including such untraditional heroes as a sentient tree-like being named Groot and an alien akin to a raccoon named Rocket, *Guardians of the Galaxy*'s tale about a group of inadvertent heroes in their quest to keep a powerful orb from reaching heinous hands has more in common both narratively and visually with *Flash Gordon* (1936) and *Dune* (1984) than it does with *X-Men, Spider-Man, Iron Man,* or *The Dark Knight.* While the characters were unknown to most moviegoers before the film's release, *Guardians of the Galaxy*'s success allowed Marvel to make its cinematic universe truly universal in the scope of the stories it can tell, with subsequent films like *Avengers: Infinity War* (2018) and *Captain Marvel* (2019) centered around more cosmic threats.

A steady reliance on sci-fi imagery also came with the first-ever superhero who appeared in movie theaters: Superman. His debut screen appearance, an eponymously titled 1941 animated short, opened with the destruction of the planet Krypton and young Kal-El's journey to Earth via miniature spaceship. While these otherworldly origins are not dealt with extensively in Superman's various animated efforts, a more detailed look at his home planet

arrived later in the decade with a fifteen-part serial, also called *Superman* (1948). The serial's first chapter begins with a shot that sweeps through space, moving rapidly past innumerable celestial bodies. Voice-over narration informs us, "In the far reaches of space, like a pinpoint at infinity, there once was a tiny blue star. Spanning the billions of miles that separated this star from the Earth, we discover that it was in reality a planet like our own. This was the ill-fated planet Krypton, which revolved around the brilliant sun of its own solar system while satellites like ringed moons in turn revolved around it." Establishing shots of the planet's "rugged terrain" follow, along with a matte painting of the capital city's futuristic architecture (which resembles that of earlier sci-fi serials like *Buck Rogers* [1939]).

Unlike how the animated shorts largely forgo any scenes of Superman's home world, the serial takes great care to establish the character's alien origins. Viewers witness the efforts of Superman's father, Jor-El, to convince his peers on the Kryptonian Council of their planet's perilous fate, the tragic decision to send young Kal-El to Earth as the sole survivor of his world, the cataclysmic eruptions throughout Krypton, and the rocket's swift journey through the cosmos just as the planet explodes. Rather than just present Superman as a superpowered crime fighter, the film deliberately positions Kal-El as

a "strange visitor from another world" (as described in the introduction to his 1940s radio series and 1950s television program).

Each generation of filmgoers since the 1940s has had its own cinematic iteration of the character recounting Superman's Kryptonian origins in great detail. *Superman* (1978) also begins with a long tracking shot rushing past countless stars as the opening credits roll. Just like the 1948 serial, director Richard Donner offers establishing shots of the planet's icy terrain, Jor-El's efforts with the Council, a heartbreaking good-bye to their son from Kal-El's parents, the planet's destruction, and the spaceship's journey to Earth. Donner also includes the banishment of the evil General Zod and his lackeys to the Phantom Zone, an intangible plane of reality where Krypton's criminals are imprisoned (a scenario setting up their return in *Superman II* [1980]).

Man of Steel (2013) follows this origin story closely even as it updates the scientific technologies on display. Kryptonian children are born artificially via an ancient artifact called the Codex, with Kal-El being the first natural birth in centuries. Robots assist Jor-El, who also battles Zod and his army with laser guns and flies on the back of a giant four-winged creature named H'raka. The opening visuals recall those of *The Matrix* (1999) and its sequels more than any previous Superman film, even as many

narrative aspects of the character's origin remain intact from the earlier versions.

Sci-fi elements continue throughout *Man of Steel*, including how the remains of a Kryptonian spaceship are found in the arctic. The discovery of the ship, a remnant from centuries past when the planet sent scouts to find potential outposts, serves as an inciting incident for Clark Kent to test out his superpowers (which he has long sought to deny). Zod later threatens Earth with an advanced weaponry known as a "world engine" that can "terra-form" the planet (changing it to resemble Krypton) in preparation for repopulating it with Kryptonians. The multiplanetary scope of *Man of Steel*'s conflicts dwarfs the comparatively paltry real-estate schemes of Lex Luthor in *Superman* (1978) and *Superman Returns*, as the 2013 film uses science fiction plot points and imagery throughout as it reboots the franchise for a new generation of filmgoers.

"CRIMINALS ARE A SUPERSTITIOUS COWARDLY LOT": CRIME

While Superman films regularly use sci-fi imagery, Batman movies are usually closely associated with crime cinema. The dark-alley confrontation between Bruce Wayne's parents and their killer recurs in many films, as a mugging leads to murder. Each Batman film between

1989 and 1997 typically revolves around villains with a large crew of henchman that Batman must dispense with. *Batman* depicts Gotham City as thoroughly crime ridden: the film opens with a late-night back-alley mugging, as steam rises in the distance from a manhole cover amid the strewn garbage. As the muggers count their ill-gotten assets, Batman swoops down among the shadows. One of the crooks fires four rounds into our caped hero, who soon dangles the criminal over the edge of a rooftop. We later watch as Batman pursues Jack Naiper through a dark factory, more steam rising amid the darkness. Napier is soon transformed into The Joker and kills the mob boss he formerly worked for, taking over his crime syndicate in the process.

The Dark Knight similarly shows The Joker's efforts in organized crime, beginning with a bank robbery. He later interrupts a meeting among several mob bosses, killing one of their henchman with a strategically placed pencil before eventually murdering one boss and taking over his criminal enterprise. The *Dark Knight* trilogy, especially *Batman Begins*, often feels like a 1970s detective film in the vein of *Dirty Harry* (1971) and *The French Connection* (1972) by emphasizing a more realistic tone to its violence and corruption than Tim Burton's and Joel Schumacher's Batman films. In Bruce Wayne's first appearance in the pages of *Detective Comics* in 1939, he declares that

"criminals are a superstitious cowardly lot"; cinematic versions of the character have in turn delved into the psychology of the Dark Knight's criminal antagonists.

Other comic book movies emphasize different aspects of the crime genre. *Ant-Man* is essentially a heist film, given protagonist Scott Lang's past as a master thief (and ex-con). Lang becomes a superhero only after stealing a high-tech suit that allows him to shrink. We soon learn that the suit's owner/designer, Hank Pym, has recruited the unwitting Lang to become the miniature hero Ant-Man so that he can steal another such suit from a devious business rival. From Lang's involvement with his ex-con buddies (who pull him into their robbery plans) to scenes of the mansion heist itself to Lang's encounters with the police ("Wait, I didn't steal anything! I was returning something I stole!"), *Ant-Man* is a crime caper film at its core.

Kick-Ass features a teenage vigilante's efforts to stop a Mafia boss, with warehouse battles against thuggish henchmen invoking the tropes of various gangster films. *From Hell* centers around the hunt for the serial killer Jack the Ripper, while *A History of Violence* (2005) depicts a former gangster's failed efforts to start over in a small Midwest town. *Road to Perdition* tells the story of a Depression-era mob enforcer, while both *Sin City* and *Sin City: A Dame to Kill For* (2014) present a variety of crime-oriented subplots. Each of these six films can be readily

categorized within the crime genre given their emphasis on gangsters, lawmen, murderers, and/or hit men, while their panel-based origins also place them within the ranks of the comic book movie if we accept the term as encompassing any film adapted from comics. But when we watch films like *Kick-Ass*, *Ant-Man*, and *Batman Begins* that blend genre conventions, our expectations are shaped as much by gangster films like *Scarface* (1983), heist films like *Ocean's Eleven* (2001), and detective films like *Heat* (1995) as they are by superhero cinema. When we watch comic book characters on-screen, we frequently experience an amalgamation of genre elements. The rising prominence of comic book movies is due in part to their having drawn on an increasingly wider range of genres, their tropes and emotional pleasures.

"DIDN'T I KILL YOU ALREADY?": SUPERNATURAL/HORROR FILMS:

Horror and fantasy elements further complicate looking at comic book movies as a single genre. Many films stemming from horror comics are commonly viewed as pure examples of the horror genre regardless of their source material, while other comic book films with strong supernatural or fantasy elements demonstrate the same hybridity as those drawing on such genres as action, war, crime,

and science fiction. When a new breed of films establishes recurring visual and narrative patterns, be it the musical in the 1930s, science fiction in the 1950s (earlier serials aside), disaster films in the 1970s, or comic book movies in the 1990s–2000s, we often apply the term retroactively to examples from past decades fitting the dominant patterns of the current era's films. The earlier films had been produced, marketed, and consumed according to particular genre frameworks but become understood by modern audiences as part of a longer, fragmented pattern of adapting comics to the screen throughout film history. The comic book origins of certain older horror films, for example, might have had little impact on how they were viewed in their time, with audience expectations about the horror genre the primary model for understanding these films.

Numerous horror films from the 1970s through 1990s were either adapted from or inspired by the infamous 1950s EC Comics title *Tales from the Crypt*. The 1972 film *Tales from the Crypt* adapts several stories from the comic, as does *The Vault of Horror* (1973). Both were part of a trend in anthology horror films alongside *The House That Dripped Blood* (1971), *Asylum* (1972), *Tales That Witness Madness* (1973), and *Trilogy of Terror* (1975). The anthology format was also used in *Creepshow* and *Creepshow 2* (1987), which were inspired by EC horror comics and

borrow heavily from their imagery while paying homage to titles like *Tales from the Crypt*. With a television series based on the comic enjoying success on HBO from 1989 to 1996, several spin-off films followed: *Tales from the Crypt: Demon Knight*, *Tales from the Crypt: Bordello of Blood* (1996), and *Tales from the Crypt: Ritual* (2002). These films were sold not as comic book movies but as horror films, coinciding with the cyclical patterns of popularity in the horror genre (which surged in the early 1970s and again throughout the 1980s but declined in the late 1990s as parody took hold).

The same is true of *30 Days of Night*, in which vampires prey on an Alaskan town during a month-long polar night. Bearing little comparison to other comic book films from the same decade, it was praised by some critics for reinvigorating vampire movies with its high-concept premise. Horror fans were also a prime audience for the action-horror trilogy *Blade*, *Blade II* (2002), and *Blade: Trinity* (2004), in which the titular half-vampire, half-human sword-wielding hero protects the world from vampires. The heavy gore in these films sets them apart from the earlier Batman films and their imitators as well as subsequent superhero films like *Spider-Man* and *Daredevil*. While the success of the first *Blade* film may have made Twentieth Century Fox more comfortable with green-lighting a more traditional superhero film, *X-Men*,

few filmgoers knew much about *Blade*'s panel-based origins and were not viewing Wesley Snipes as a comic book hero in the same way they watched Michael Keaton and his successors as Batman. Like *30 Days of Night*, *Blade* is a high-concept vampire film easily categorized within the horror genre.

Even films like *The Crow* and *Spawn* that emerged as part of the darker-themed mid-1990s cycle have strong supernatural elements in their treatment of characters who return from the dead in search of justice. The type of Faustian bargain that turns the former soldier Al Simmons into Spawn is also central to *Ghost Rider* and its sequel, *Ghost Rider: Spirit of Vengeance* (2012), in which the stuntman Johnny Blaze is transformed into a demonic motorcyclist after selling his soul to Mephistopheles. The supernatural has long been part of the horror genre, dealing with such forces as ghosts, demons, the devil, and the occult. *Constantine* sees the demon hunter John Constantine confront an angel and destroy various demons before facing off against Satan himself. *Hellboy* and *Hellboy II: The Golden Army* (2008) feature a demon as the title hero who does battle (alongside merman Abe Sapien and their teammates in the Bureau for Paranormal Research and Defense) against a Nazi sorcerer and various H. P. Lovecraft–inspired beasts ("Didn't I kill you already?" cries Hellboy as he fights a tentacled monster).

The supernatural is also the main focus of *Doctor Strange*, which chronicles a former neurosurgeon's journey to become the "Sorcerer Supreme." While the character is part of Marvel's cinematic universe of superheroes, the supernatural imagery in *Doctor Strange* is the work of director Scott Derrickson, who wrote and directed *The Exorcism of Emily Rose* (2005), *Sinister* (2012), and *Deliver Us from Evil* (2014). The horrific and supernatural imagery in films like *Doctor Strange*, *Ghost Rider*, *30 Days of Night*, and *Hellboy* brings with it a different set of expectations than do straight-up superhero efforts. The demons, vampires, and things that go bump in the night pervading these movies offer viewers yet another hybrid filmgoing experience that lends a different level of genre expectations to the mental model of the comic book movie.

"I CAN'T RELATE TO 99 PERCENT OF HUMANITY": COMIX AND AUTOBIOGRAPHY

Perhaps the most complicated types of films to bear the "comic book movie" label are those based on autobiographical series, as well as those adapted from underground and independent comics. Just as numerous smaller publishers like Drawn & Quarterly, Fantagraphics, Oni Press, and Top Shelf offer comics readers an alternative to the overabundance of capes, masks, and

superpowers on display in Marvel and DC titles, there have been similar alternatives to superhero cinema. Much like how Steve Buscemi's awkward, antisocial character Seymour proclaims in *Ghost World* that he "can't relate to 99 percent of humanity," fans of underground and independent comics often distance themselves from the fan base of superhero comics (few fans engage in Comic-Con cosplay for the characters of Art Spiegelman, Chris Ware, Daniel Clowes, or Marjane Satrapi, for instance). These types of comic books are often called "comix," the *x* designating their alternative status from mainstream titles.

Films based on independent comics, such as *Fritz the Cat* (and its follow-up, *Nine Lives of Fritz the Cat* [1974]), usually reach a different audience than those based on Marvel and DC titles. Based on characters created by Robert Crumb and full of sex, drugs, and counterculture, *Fritz* takes aim at the social norms surrounding politics, religion, marriage, and sexuality. Although *American Splendor* didn't earn an X rating like *Fritz*, it was also based on the work of an underground comix legend, Harvey Pekar. The autobiographical film chronicles Pekar's life as a disgruntled file clerk and comics author, and it won the Grand Prize at the 2003 Sundance Film Festival (considered the leading festival in the United States for independent cinema). The film thrived in the art-house theater circuit, as did *Ghost World*, although neither gained a

wide multiplex release. Based on Daniel Clowes's story of two misfit girls navigating life after graduating from high school, *Ghost World* didn't earn anything close to the box-office returns of *X-Men* or *Spider-Man*, nor did its producers ever intend it to. But the film's critical success was followed by an Oscar nomination for Best Adapted Screenplay, allowing for films like *American Splendor* to follow, along with other adaptations of Clowes's work, like *Art School Confidential* and *Wilson* (2017).

Much like the counterculture audiences who saw *Fritz the Cat* and the art-theater viewers of *Ghost World* and *American Splendor*, audiences of *Persepolis* aren't watching it with the expectation of seeing a comic book movie in the same sense as those watching an Avengers or Justice League film.[2] Based on Marjane Satrapi's memoir about her life as a young girl in Iran during the late 1970s revolutionary period, *Persepolis* is a comic book movie only in the sense that it stems from a graphic novel. Like other films adapted from autobiographical, underground, and independent comics, it doesn't feature valiant heroes, super or otherwise. Instead, the focus is on everyday people, some in difficult situations and others in more mundane ones. In each case, the images and narratives that most filmgoers associate with the comic book movie as it is commonly understood are nowhere to be found.

• • •

While comic book movies are not as easily categorized by their use of repeating character types, props, settings, themes, or narrative patterns, it seems as if the label will endure, for better or worse. Most such films depict heroes righting wrongs and stopping evildoers, but the same is true of most action, western, detective, war, jungle adventure, and science fiction films. In the comic book industry, publishers and fans differentiate between superhero comics, crime comics, horror comics, romance comics, war comics, western comics, and autobiographical comics, among many others. The obvious differences between each type make the "comic book movie" label a problematic one if we try to think of these films as a unified genre.

Perhaps it is better to consider comic book movies in the same sense that French critics in the 1940s applied the term "film noir" to a group of American films from disparate genres (gangster and detective films, gothic dramas, thrillers, melodramas, etc.). Some film theorists now consider film noir as more of a style than a genre, which as chapter 4 shows is also true of comic book movies. To fully understand the widespread appeal of comic book movies, we have to look at larger factors than just their genre elements, such as how these films exemplify age-old mythic qualities and reflect pressing political tensions.

2

MYTH

One of the strongest pleasures of comic book movies is watching people greater than ourselves facing threats that we could never personally prevent and battle villains we could never hope to vanquish while using powers, abilities, and technologies we could never possess. While James Bond, John Rambo, Ethan Hunt, John McClane, and other action-movie stalwarts also face impossible situations, nefarious criminals, and overwhelming odds, all are at their core vulnerable human beings—often suffering defeat and serious injury, reminded of their own mortality while testing their limits. Action-film audiences in turn imagine that with enough training and adrenaline, we too might thrive in the face of danger, negotiate explosive situations, and capture dangerous enemies. At the same time, we recognize the fallibility of these characters: Bond fails his physical examination while recovering from a gun-shot wound in *Skyfall* (2012); McClane's bare feet are ripped to shreds while running across broken glass in *Die Hard* (1988).

In contrast, comic book movies usually offer characters who are more than human and who act in ways that we in the audience can never possibly match. These are usually superhero films, but not always (as seen in the gravity-defying fight scenes of *Scott Pilgrim vs. the World*, the life-after-death resurrection of *The Crow*, the shape-shifting chaos of *The Mask*, and the elemental transformation of *Swamp Thing*). Superhero cinema regularly presents characters who fly, stop bullets with their bare hands, transform their bodies, read minds, and possess astonishing strength. Some are literal gods (Thor), are descended from gods (Wonder Woman), or possess the combined powers of multiple gods (Captain Marvel / Shazam). In place of terrorists like Hans Gruber and Ernst Stavro Blofeld, comic book movies offer potential world conquerors like Ultron (*Avengers: Age of Ultron*) and Apocalypse (*X-Men: Apocalypse*), superpowered villains like General Zod (*Superman II, Man of Steel*) and Magneto (*X-Men, X-Men: First Class*), along with technologically enhanced foes like Doctor Octopus (*Spider-Man 2*) and Doctor Doom (*Fantastic Four* [2005], *Fantastic Four* [2015]). In the face of such opponents, Bond, McClane, Jason Bourne, Martin Riggs, and other action-movie icons would be less than formidable.

While action movies allow viewers to imagine the hero within themselves, comic book movies present fantastic

heroes who we know we can never become. Despite the fantasies portrayed, these movies tell stories about what it means to be human in an era of rapid technological change and cultural transformation. In many ways, the role that these films play in our culture now are similar to the role of myths in ancient civilizations, embodying our hopes and fears about how societal forces affect us.

While it's obviously a stretch to say these films have the same type of direct, active influence in people's lives in the ways that Greek mythology did in ancient Greece or that Haida mythology still does within Canadian First Nations tribes, comic book movies do provide allegories for how we navigate our place in the world. They tell stories, for instance, about the roles played by science and technology in contemporary life, about the evolution of the human body and our cultural understanding thereof—all foundational parts of how we understand ourselves, our values, and our society. While some viewers might watch these movies as mere tales to astonish, there are vital allegories behind the amazing fantasies they present.

OF GODS AND (SUPER) MEN

The connections between comics and myth are regularly explored by comics scholars and journalists,[1] while creators often cite myths as sources of inspiration. The author

Neil Gaiman recounts that reading about Thor in the pages of Marvel comics inspired a love of Norse mythology (11). He later brought this mythological focus to his acclaimed series *The Sandman*, which draws on myths from numerous cultures and eras. The discourse of comics-characters-as-myths even makes its way into Quentin Tarantino's *Kill Bill: Vol. 2* (2004). Here, David Carradine delivers a monologue invoking the mythological nature of superheroes in general and commenting specifically on the mythic qualities on display in *Superman* comics:

> As you know, I'm quite keen on comic books, especially the ones about superheroes. I find the whole mythology surrounding superheroes fascinating. Take my favorite superhero, Superman. Not a great comic book, not particularly well drawn. But the mythology. The mythology is not only great; it's unique.... Now, a staple of the superhero mythology is there's the superhero and there's the alter ego. Batman is actually Bruce Wayne; Spider-Man is actually Peter Parker. When that character wakes up in the morning, he's Peter Parker. He has to put on a costume to become Spider-Man. And it is in that characteristic Superman stands alone. Superman didn't become Superman. Superman was born Superman. When Superman wakes up in the morning, he's Superman. His alter ego is Clark Kent. His outfit with the big red "S," that's the blanket he was wrapped in as a baby

when the Kents found him. Those are *his* clothes. What Kent wears—the glasses, the business suit—that's the costume. That's the costume Superman wears to blend in with *us*. Clark Kent is how Superman views us. And what are the characteristics of Clark Kent? He's weak, he's unsure of himself, he's a coward. Clark Kent is Superman's critique on the whole human race.

Tarantino's emphasis on the alter ego positions superheroes as modern-day myths, and while the notion of using these myths to "critique" humanity may seem harsh, it does point, however bluntly, toward a larger cultural role for superhero cinema. The dual lives led by Clark Kent, Bruce Wayne, and Peter Parker connect to what the sociologist Émile Durkheim calls the "duality" of human beings. Describing how a "distinctive feature" of being human is "the constitutional duality of human nature," Durkheim sees the human body and the soul as two separate entities. He believes this duality affects us psychologically but stresses that "the traditional antithesis of body and soul is not an empty mythological conception, without foundation in reality. It is indeed true that we are double," and to be human means that we are aware of and affected by this duality (35). Alter egos are a physical extension of this duality, reflecting the central tension between body and soul described by Durkheim, who sees

the two as often "in conflict" (much as the needs of a civilian identity regularly create conflicts for a superhero).

The alter ego was central to the mythology of ancient cultures in China and Central America, commonly in the form of a "man-beast motif" or with animals serving the role of "companion, or alter-ego" (Chang). Animal alter egos (including insects, reptiles, and amphibians) are a steady presence in superhero films, with characters like Batman, Spider-Man, Catwoman, Black Panther, Wolverine, Ant-Man, and The Crow all headlining their own films, while The Falcon, Black Widow, Batgirl, and Robin play supporting roles. Villains include The Penguin, Sabretooth, Killer Croc, Doctor Octopus, The Lizard, The Toad, and The Rhino, while anthropomorphic characters like Rocket Raccoon, Howard the Duck, and the Teenage Mutant Ninja Turtles have also made cinematic appearances.

While Western culture doesn't place the same value on animal alter egos as, say, Haida culture does on the raven (a shape-shifter who brought food, water, and housing sources, allowing society to flourish), the recurrent duality of comics characters does connect to larger, centuries-old traditions of storytelling with mythological and spiritual purposes. Direct religious analogies are often in play with superheroes, none more than Superman. John T. Galloway Jr.'s 1973 book *The Gospel According*

to Superman laid out the connections between Kal-El and Christianity several years before Richard Donner incorporated Christian themes into *Superman* (1978) and *Superman II*. The scene in which Marlon Brando's Jor-El places his infant son inside a rocket ship and sends him off into the cosmos to avoid Krypton's destruction echoes the placement of the baby Moses in a basket among the reeds of the Nile to avoid death at the hands of the Pharaoh's soldiers. As Jor-El says good-bye to his son, his dialogue draws on the Christian idea of the holy trinity: "You will carry me inside of you, all of the days of your life. You will make my strength your own and see my life through your eyes, as your life will be seen through mine. The son becomes the father, and the father the son."

Jor-El adds, "They can be a great people, Kal-El. They wish to be. They only lack the light to show the way. For this reason above all, their capacity for good, I have sent them you . . . my only son." The parallels with Christianity are unmistakable here, combining elements from the biblical passage of John 3:16, "For God so loved the world that he gave his only begotten son," along with John 8:12, in which Christ states, "I am the light of the world: he that followeth me shall not walk in darkness, but shall have the light of life." Jor-El's dialogue was reused in *Superman Returns*, with the character's religious parallels remaining as a new millennium began.

But even if some viewers reject the spiritual analogies behind their favorite on-screen superheroes, characters like Superman still fulfill a mythic role.[2] When we watch a Superman film, we put our faith in the image of a superhero as representing a larger-than-life figure. This process is not just the common suspension of *disbelief* inherent in all fiction; it involves a degree of *actual belief* in something greater than ourselves. The tagline for the 1978 *Superman* film was, "You will believe a man can fly." Special effects aside for now, this slogan invites audiences to believe in the ability of a human being to be more than human, to believe that the physically impossible is possible. Such belief might otherwise be described as faith; if we didn't have faith in the on-screen visages of comic book heroes, we would instead find these images preposterous and unacceptable—perhaps even improper and unnatural, like a plastic houseplant or a toddler wearing makeup.

The word "fidelity" stems from the Latin root word for faith, which is why we ask whether films are faithful to their source material when considering questions of fidelity in adaptation. Faith can also be defined as religious belief that isn't based on physical proof, so when we put our trust in comic book film imagery, we also put aside our doubts about whether superpowered men and women really exist. As the role of organized religion in society declined in the last few decades of the twentieth

century (with church attendance rates lower than those of earlier generations),[3] Hollywood increasingly offers the public new stories of godlike heroes performing miraculous feats for the betterment of humankind.

Faith in something larger than oneself is a fundamental instinct. The comics writer Grant Morrison in turn describes Superman as "a perfectly designed emblem of our highest, kindest, wisest, toughest selves" (xv), representing "some of the loftiest ambitions of our species":

> He was brave. He was clever. He never gave up and he never let anyone down. He stood up for the weak and knew how to see off bullies of all kinds. He couldn't be hurt or killed by the bad guys, hard as they might try. He didn't get sick. He was fiercely loyal to his friends and his adoptive world. He was Apollo the sun god, the unbeatable supreme self, the personal greatness of which we all know we're capable. He was the righteous inner authority and lover of justice that blazed behind the starched-shirt front of hierarchical conformity.
>
> In other words, then, Superman was the rebirth of our oldest idea: He was a god. His throne topped the peaks of an emergent dime-store Olympus, and, like Zeus, he would disguise himself as a mortal to walk among the common people and stay in touch with their dramas and passions. (15–16)

The ideas about gods, mortals, and morality invoked by Morrison surface again in *Batman v. Superman: Dawn of Justice*. The film abounds with (perhaps heavy-handed) religious and mythic references, with Superman described as a "messiah" and "savior," while Batman is called "a devil." Figures from Greek mythology like Zeus and Prometheus are invoked, as is Icarus when Lex Luthor tells the villainous General Zod that he "flew too close to the sun" in his attempt to kill Superman. Bruce Wayne's butler, Alfred, describes how "men fall from the sky, gods hurl thunderbolts," while Luthor proclaims, "Devils don't come from hell beneath us, no. They come from the sky."

Luthor also raises ethical and theological questions as he compares Superman to God: "Ah, because that's what God is. Horus. Apollo. Jehovah. Kal-El. Clark . . . Joseph . . . Kent. See, what we call God depends on our tribe, Clark Joe, because God is tribal. God takes sides. No man in the sky intervened when I was a boy to deliver me from Daddy's fists and abominations. I figured out way back if God is all-powerful, he cannot be all-good. And if he is all-good, then he cannot be all-powerful. And neither can you be." Even as film viewers put their faith in comic book crusaders, such hero worship is frequently questioned on-screen as various characters debate the societal roles and values of superheroes. If such figures are truly

larger than life, if they represent our highest ideals and aspirations, and if they are the closest thing to modern mythological figures that popular culture currently has to offer, then comic book movies are a forum for exploring religion, spirituality, and the mythic using colorfully costumed characters as allegories for that which lies beyond the realm of mere mortals.

ACCIDENTAL HEROES

Some comic book heroes are born into greatness. As the son of Odin—ruler of the kingdom of Asgard—Thor was raised to be a warrior and future king. His destiny was shaped from the moment of his birth, fueling an eventual clash with his resentful half brother Loki in *Thor* and *The Avengers*. Arthur Curry must similarly accept his destiny as the king of Atlantis in *Aquaman* (2018). Other heroes have greatness thrust on them. Hal Jordan was chosen to be Green Lantern because his fearlessness and bravery eclipsed that of the people around him. Still others become superheroes not by birthright or because they are deemed worthy but rather by sheer happenstance: Spider-Man, The Fantastic Four, The Hulk. All are granted their powers through freak occurrence. Together they form a pattern within comic book movies: the myth of the accidental hero.

Not all myths stem from the oral traditions of ancient cultures. The communications theorist Marcel Danesi defines myths as "metaphorical narratives" used "to explain the origin of something in metaphysical ways" (152). For the ancient Greeks and the Romans, myths were used to account for why things happened in nature. As centuries passed, the myths we use to make sense of the world changed. Some emerged from literature, like how Mary Shelley's *Frankenstein* spawned the "Frankenstein myth" about the ethics surrounding scientific and technological progress. As the decades ensued and new advancements emerged (such as the shift to electronic and then digital media), the Frankenstein myth has been applied to new contexts within new cultures. Indeed, *Frankenstein*'s subtitle is "The Modern Prometheus," showing how a Greek myth about a Titan punished for stealing fire from Zeus and giving it to mortals was updated to serve nineteenth-century concerns about scientific progress.

The myth of the accidental hero is another such updating. Bruce Banner (The Hulk) and Reed Richards (Mister Fantastic of The Fantastic Four) are scientists whose research leads to unintentional transformation, while Peter Parker (Spider-Man) is a student whose keen interest in science leads to his radioactive spider bite at an exhibit. All are heroes born out of not deliberate intent but

unexpected circumstance. Victor Frankenstein actively
defied the natural order to create new life ("In the name
of God, now I know what it feels like to *be* God!" shouts
Colin Clive in the 1931 film version), only to find himself
hunted by his creation; an updated version arrives in
Avengers: Age of Ultron when Tony Stark's artificial prog-
eny defies its programming and turns on its creator (and
all of humanity). Human beings generally believe that
technology improves their quality of life. From the Indus-
trial Revolution to the Internet, new scientific advance-
ments bring with them significant pleasures, potentials,
and profits. Tony Stark's fortune stems from his high-tech
inventions in *Iron Man*, Scott Lang's acquisition of a suit
with shrinking powers leads to redemption with both his
family and the law in *Ant-Man*, while Hal Jordan's power
ring allows him to save the world from destruction in
Green Lantern.

But new technologies and media also cause unforeseen
effects on society, requiring changes in how business, pol-
itics, education, and other institutions function. *Iron Man
2* (2010) sees Stark in a struggle with the US military over
his high-powered suits, with his best friend, Lt. Col. James
Rhodes, donning a silver "War Machine" suit of armor.
Watchmen depicts the nuclear destruction of New York
City, while *X-Men: Days of Future Past* features a squad of
government-led robotic enforcers/assassins.

Unintended consequences of technology are a recurrent theme in comic books and their adaptations, with scientific accidents key to the origins of countless superheroes. Banner, Parker, and Richards (along with the rest of The Fantastic Four: Ben Grimm, Sue Storm, and Johnny Storm) gain their powers in inadvertent ways (an insect bite, a blast of gamma radiation, or cosmic rays), often struggling to accept their transformations. Their path to becoming heroes was much different than the ways in which Bruce Wayne and Tony Stark became self-made heroes thanks to their intelligence and business acumen in *Batman Begins* and *Iron Man*. Films like *Spider-Man, Hulk,* and *Fantastic Four* (2005) show us what can happen when technology goes awry, granting power to those who never asked for it.

BODIES

The transformations undergone by Spider-Man and his amazing friends represent not just concerns for technology's larger societal effects but also its immediate impact on the human body—both its physical abilities and how we understand it in abstract terms. Comic book movies regularly offer stories about how technology alters what the human body is capable of. In both *Captain America* and *Captain America: The First Avenger*, the scrawny army

reject Steve Rogers volunteers for an experimental "super soldier" project and is transformed into a perfect physical specimen with superior strength, speed, and stamina. Cap's origin offers audiences hope for the future of medical technology—bodily weakness turned into vitality, frailty into might.

This type of bodily makeover is a common one in superhero comics and has been argued by some people (including anticomics crusaders like Frederic Wertham in the 1950s; see also Nyberg) as a detrimental wish-fulfillment fantasy for young men wishing to be more muscular, powerful, and/or heroic—perhaps even more "manly." Advertisements for Charles Atlas's exercise program ran regularly in comic books throughout the 1940s to 1970s, promising to transform the "soft, frail, skinny or flabby" into "a real he-man in double-quick time": "Let me *prove* I can make *you* a *new man!*" the ad boasts. Developments in exercise equipment now make Atlas's program seem old-fashioned, while advancements in nutritional supplements now allow weightlifters to gain muscle mass more rapidly. But while it might be tempting to see modern comic book cinema as a mere extension of Wertham's wish-fulfillment argument in an era of rising gym memberships and yoga pants purchases, these films offer us allegories about how technology is changing the human body on a biological level and about cultural acceptance

of new definitions of the body in connection with issues of sexuality and gender.

In an era of human cloning and stem-cell research, technology can now change us on a biological level and create new life altogether, updating the Frankenstein myth further. *Justice League* (2017) features Victor Stone, aka Cyborg, whose body is reconstructed using cybernetic materials after a terrible accident. With the line blurred between where the man ends and the machine begins, Stone represents an evolution of the human body through technological enhancement (a combination of "organic and biomechatronic body parts," the film tells us). The communication theorist Marshall McLuhan described technologies as extensions of the human body—the wheel as an extension of the foot's ability to travel, the computer an extension of the brain's cognitive ability, and so on. Characters like Cyborg embody this extension on a literal level. Whereas the technology behind Iron Man's suit allows Tony Stark to do things his own body cannot, Cyborg's body becomes one with the technological apparatus—his central nervous system is interconnected with digital machinery in ways that wearable technology products like Fitbit and Google Glass have only begun to explore.

This bodily focus also extends to the microscopic level, with numerous comic book movies reveling in close-up

shots of blood cells. *The Incredible Hulk* depicts Banner's blood being overcome by gamma radiation, his red cells turning green in the process. Biological mutation is at the heart of the X-Men franchise; mutants are born with genetic differences that later become manifest in the form of superpowers. The fact that mutants' extraordinary abilities are biologically latent and not acquired by chance, fate, or deliberate choice results in the X-Men characters facing discrimination and government regulation. In the actual comics, the X-Men faced the Mutant Registration Act, while the robotic sentinels in *X-Men: Days of Future Past* hunt down mutants under the orders of President Richard Nixon.

In both the comics and their film adaptations, mutants are used to explore themes of bodily, sexual, and racial difference—visible (and invisible) otherness. As the comics scholar Ramzi Fawaz argues in *The New Mutants: Superheroes and the Radical Imagination of American Comics*, "the concept of 'mutation' or genetic diversity in the Marvel Universe worked as an elastic metaphor for a vast array of differences based on race, class, gender, sexuality, generation, and ability that would later become the mainstay of late 1960s and early 1970s cultural politics" (124). Bryan Singer, who has directed four X-Men films to date, says he was drawn to the franchise as a gay man because he identified with the comics' theme of

isolation: "mutancy is discovered at that age in puberty when you're different from your whole neighbourhood and your family and you feel very isolated" ("Bryan Singer"). Recent X-Men films can add issues of transgender rights to the metaphors that the films' characters represent, with transgendered bodies and public spaces (such as bathrooms) the subject of current political debates and legal rulings.

Comic book movies regularly offer images of human bodies being transformed. Sometimes science produces superior results, such as Captain America's super-soldier serum. Other times the changes leave their heroes hideously scarred like *Deadpool* (who describes himself as looking "like a testicle with teeth"). Myths are regularly used to understand the body and its evolutions, from the way Artemis guided young Greek women through puberty to the raven's role in the creation of humankind in Haida mythology to the biblical creation of Adam from the ground's dust and the formation of Eve from Adam's rib. Myths help explain who we are and how we move through the stages of life. "It's who we are now. Maybe it's who we're meant to be," says Reed Richards to his teammates about their newfound powers in *Fantastic Four* (2015). As technological advancements and cultural change force reconsiderations about the forms and functions of the human body, comic

book movies offer audiences mythic tales of bodily
metamorphosis and enhancement.

ORIGIN STORIES

Origins are crucial to comic book movies, much as they
are to myths. "The origin is the soul of [humanity],"
said the mythologist Joseph Campbell. "The problem is
not to lose touch with them," he pleaded (46). As new
technologies usher in rapid cultural change and bodily
enhancements, audiences turn to fantasy characters like
Harry Potter and comic book heroes like Wolverine,
Peter Parker, Hellboy, Star-Lord (from *Guardians of the
Galaxy*), the Winter Soldier (from *Captain America: The
Winter Soldier*), and Superman, all of whom seek the truth
about where they come, who their parents really were,
and/or how they gained their fantastic abilities. *Hellboy*
begins with Professor Bruttenholm (Hellboy's surrogate
father) asking, "What is it that makes a man a man? Is it
his origins, the way things start? Or is it something else,
something harder to describe?" Such dialogue points to a
central theme of comic book movies: exploring the ways
in which personal identity is formed.

Nearly all films based on comics have recounted the
origins of their main characters. The comics scholar Scott
Bukatman notes that "superhero films are even more

obsessed with origin stories than the comics themselves" ("Why" 121). So central are these starting points that audiences delight in the retelling of familiar origins.[4] Peter Parker's transformation into the heroic web slinger was told twice in *Spider-Man* and *The Amazing Spider-Man*. With the latter film rebooting the franchise, the backstory surrounding Richard Parker (Peter's father) is further established, nuancing the basic story that most viewers were already familiar with from the earlier film. In both versions, we watch as Peter is attacked by the high-school bully Flash Thompson, gets bit by a radioactive spider in a laboratory, discovers his amazing powers, fails to stop a thief who later kills Peter's uncle Ben, readjusts to life as a high-school student with his newfound capabilities, creates his own costume, tests out the full extent of his arachnid-like abilities, makes his public debut as Spider-Man, and tracks down his uncle's killer. These events take up roughly the first half of each film, making *The Amazing Spider-Man* as much a remake of *Spider-Man* as it is a reboot. Yet the exploration of Richard Parker's work as a scientist, his relationship with the film's villain (The Lizard), and the hint of a larger mystery surrounding his father's life serve to give the film its own take on this myth of an accidental hero and the formation of his identity.

In *Superman* (1978), a young Clark Kent creates an arctic Fortress of Solitude using a crystal from the rocket

ship that brought him to Earth. Summoning his father, Jor-El, via the ship's crystals, the first question he asks is one that strikes at the heart of most myths: "Who am I?" With Kent's Kryptonian heritage also explored in the 1948 *Superman* serial and *Man of Steel*, each generation of filmgoers has had their own version of Superman's origin story. The murder of Bruce Wayne's parents as the flashpoint for his eventual fight against crime is recounted in *Batman* and *Batman Begins*, while the latter also recounts the years of travel and training that prepared him for his role as Gotham's Dark Knight. Other films, including *Batman Forever* (1995) and *Batman v. Superman: Dawn of Justice*, include formative moments in young Bruce's life, such as falling into a bat-laden subterranean cave.

Few comic book characters debut on-screen without having their origin story told in some way; we rarely follow their adventures starting midcareer. *Iron Man* begins by showing us how Tony Stark built his first suit of armor. *Captain America: The First Avenger* chronicles Steve Rogers's journey to becoming a super soldier. *Thor* shows us the youthful rivalry between the god of thunder and his half brother Loki, followed by their arrival on earth. *Green Lantern* follows Hal Jordan's initiation into an intergalactic corps of peacekeepers. *Kingsman: The Secret Service* depicts Gary Unwin's recruitment into a league of secret agents. *Wonder Woman* recounts Princess

Diana's childhood on Themyscira and her introduction to the world outside her Amazonian homeland. *Deadpool* depicts Wade Wilson's agonizing transformation into a superpowered mercenary. *Doctor Strange* shows us Stephen Strange's apprenticeship with a master sorcerer.

This pattern extends throughout the history of comic book movies. Since the rise of blockbuster cinema in the late 1970s, comic book movies have focused on the origin stories of heroes (*Superman* [1978], *Supergirl* [1984], *The Rocketeer*, *The Crow*, *Steel*, *Blade*, *Daredevil*, *Hulk*, *Catwoman*, *The Punisher* [2004], *The Spirit* [2008], *Kick-Ass*, *Ant-Man*), creatures and supernatural entities (*Swamp Thing*, *Howard the Duck*, *Teenage Mutant Ninja Turtles* [1990], *Spawn*, *Hellboy*, *Ghost Rider*), and groups (*Mystery Men*, *X-Men*, *Fantastic Four* [2005], *Watchmen*, *X-Men: First Class*, *Suicide Squad*, *Justice League*). While it's tempting to see this emphasis on origins as a symptom of modern corporate logic in an era of tent-pole franchises, prequels, and continuity reboots, the same approach to storytelling is seen in the 1970s through 1990s, not to mention how 1940s serials like *Adventures of Captain Marvel* and *Superman* (1948) spend ample time recounting the origins of their heroes.

• • •

Myths are born when momentous events need explaining through allegorical stories. When social, technological,

or evolutionary changes occur, these processes can be further understood through mythic narratives offering a creative, comparative, and/or cautionary tale that shapes a certain phenomenon in a new light. Peter Parker's spider bite and Bruce Banner's gamma radiation are stories about the risks and rewards of modern science. *Deadpool* and the X-Men franchise offer allegories about how technological and cultural developments affect our understanding of the human body and how social forces seek to control the ways our bodies are defined. These stories aren't always direct in their handling of their larger political and moral underpinnings, but they still function as compelling rereadings of the pressing concerns represented. Comic book movies can offer more than just colorful escapism. They can remind us of the larger forces at work that shape our societies, cultures, and identities.

3

POLITICS

While many myths offer hope, explanation, renewal, and resolution, the political subjects and imagery in some comic book movies center around destruction, militarism, persecution, and anarchy. If myths can show us how things began, comics adaptations frequently use political themes, images, and allegories to make things fall apart. Many such films use politics (in the governmental sense) directly, as the basis of their characters or narratives. Others stand as powerful metaphors for their current political landscape. Some films are about war, others terrorism. Many portray government corruption, covert espionage, or secret organizations. While films like *Superman* (1978) offer viewers the optimism of an invulnerable protector, others like *The Dark Knight* present all-too-real accounts of armed madmen causing chaos that even the most watchful protectors cannot prevent.

Explorations of heroism and morality in comic book films are often filtered through political themes and meta-

phors. During World War II, the Allied forces were aided on-screen by characters like Batman and Spy Smasher. Terrorism is a prevalent concern in many of the Iron Man and Captain America films. Both *V for Vendetta* (2005) and *The Dark Knight Rises* (2012) present modern culture as marked by political unease and resistance. In *Comics and Ideology*, Matthew P. McAllister, Edward H. Sewell Jr., and Ian Gordon outline how comics can reflect issues of social power, asking, "how may comics challenge and/or perpetuate power differences in society? Do comics serve to celebrate and legitimize dominant values and institutions in society, or do they critique and subvert the status quo?" (2). Comic book movies offer equally valuable case studies for how these issues are represented in popular culture.

"GLAD TO FIGHT FOR IT": WORLD WAR II AND THE BIRTH OF COMIC BOOK CINEMA

Comic book movies began in the early 1940s, a few years after the comic book publication format appeared on newsstands with such popular titles as *Famous Funnies, More Fun Comics, Detective Comics,* and *Action Comics.* Hollywood soon took notice, adding costumed characters to its ranks of cliffhanger serials and animated shorts (alongside those based on newspaper strips like *Flash*

Gordon, Buck Rogers, Dick Tracy, and *Popeye*). In 1941, Paramount released the first of several animated adventures starring the Man of Steel with *Superman,* a ten-minute short in which he rescues Lois Lane from a mad scientist and his giant death ray. When the United States entered World War II following the attack on Pearl Harbor on December 7 of that year, Hollywood sought to boost morale with numerous war-themed tales in which Axis plans are thwarted and foes captured.

The results of these patriotic endeavors were often unflattering in hindsight. Their vilification of Japanese spies and saboteurs embraced abhorrent representations of racial otherness. September 1942 saw the release of *Japoteurs,* in which Superman captures Japanese agents who are after the world's largest bomber airplane. "Help! Help! Japs are stealing the giant bomber," says Lois via the cockpit's microphone. The film depicts the Japanese spies as stocky, buck-toothed, and ultimately ineffectual: "Okay, little man. You win!" taunts Superman as he prepares to rescue Lois and halt the aircraft's abduction.

Further anti-Japanese sentiments are on display in Batman and Robin's screen debut—Columbia's 1943, fifteen-chapter serial *Batman.* Here the Dark Knight is billed as "America's number-one crime fighter," and the Boy Wonder is described as "his young, two-fisted assistant," with the film delivering a relatively faithful rendition of the

characters aside from a few strategic changes.[1] The film's opening narration tells of the duo's continuing efforts to prevent an Axis victory in World War II, stating that together, the heroic pair "represent American youth who love their country and are glad to fight for it. . . . And in this very hour when the Axis criminals are spreading their evil over the world, even in our own land, Batman and Robin stand ready to fight them to the death." The caped crusaders—who, we are told, have recently been made secret government agents in the wake of the United States' entry into World War II—spend fifteen chapters before finally thwarting the villainous Dr. Daka, a Japanese spy.

Daka's efforts to steal both Gotham City's radium supply (to power his disintegration ray gun) and US military secrets position the serial's narrative as both war-era propaganda and traditional 1940s potboiler serial with action and science fiction elements. The film contains patriotic, anti-Japanese dialogue such as, "Listen, Daka, or whatever your name is. I owe allegiance to no country or order but my own. I am an American first and always, and no amount of torture conceived by your twisted Oriental brain will make me change my mind." It also cements Daka's evil nature with announcements of his loyalty to Japan's role as a US enemy: "I am Dr. Daka, humble servant of his majesty Hirohito, heavenly ruler and the Prince of the Rising Sun. By divine destiny my

country shall destroy the democratic forces of evil of the United States to make way for the new order, an order that will bring about the liberation of the enslaved people of America." Such lines deliberately drew, no doubt, a slew of hisses and boos from 1940s theatrical audiences.

But these war-related references occur only sporadically throughout the film, which otherwise follows a formula seen in numerous serials of this period whereby the hero battles a crooked criminal boss armed with pseudo-technological weaponry (usually imaginary, occasionally half inspired by scientific reality). In this case, Daka uses a machine that makes mindless zombies out of ordinary men, controlling them via a radio-controlled headpiece. Such sci-fi gimmicks were commonplace in serials, especially in the hands of their villains. Daka might have easily been replaced by a more generic (usually masked or hooded) villain and the film's war-themed elements removed with minimal effect on the narrative. As the comics scholar Will Brooker points out, "The propaganda element is kept separate from the Batman 'mythos'" in the serial "and consists primarily of voiceover, or of scenes which exclude Batman himself. . . . We are given 'propaganda,' and 'Batman,' but never an integrated version of the 'propaganda Batman'" (87).

Both *Japoteurs* and *Batman* cast their superheroes as de facto soldiers in the war against fascism, even if they only

indirectly enforced militaristic discourses through their actions. Surprisingly, there was no Wonder Woman film made in this era, despite the character's popularity. Several jungle-adventure serials of the 1940s featured female heroes, including *Jungle Girl* (1941), *Perils of Nyoka* (1942), and *The Tiger Woman* (1944), while crime/adventure serials like *Brenda Starr, Reporter* (1945) and *Daughter of Don Q* (1946) placed women at the center of the action (see Higgens). Given how World War I plays a large role in the 2017 film *Wonder Woman*, a World War II–themed Wonder Woman entry would have seemed a natural fit for the 1940s serial market, basing its narrative around any number of genres.

Serial stalwart Republic Pictures did produce a war-era cliffhanger featuring the Fawcett Comics hero Spy Smasher in 1942, in which he stops a ring of Nazi spies. But when it came time for Republic to make *Captain America* (1944), the studio abandoned the character's military background and turned him into the crime-fighting district attorney Grant Gardner (who is hot on the trail of a standardized serial villain named The Scarab, who seeks the ultimate weapon—a "Dynamic Vibrator"). Clearly not all war-era superhero serials used patriotism to sell tickets.

The Sad Sack (1956), based on Martin Baker's comic strip and its subsequent comic books, even offered up war

as the subject of ridicule thanks to the comedic antics of Jerry Lewis. Adaptations of comics shifted to television for most of the 1950s through 1970s, with only a few films based on comic book heroes produced in this period.

When comic book movies appeared in theaters again with any regularity by the early to mid-1980s, the United States was no longer at war—the conflict in Vietnam wrapping up by 1975. Cold War tensions inspired the nuclear-themed *Superman IV: The Quest for Peace* (1987), but few people cared for the failing franchise by that point. Comic book movies were largely unconcerned with overt political themes in the 1990s: Batman fought colorful villains two by two in various sequels; Ninja Turtles ate pizza and danced alongside Vanilla Ice; Jim Carrey donned a green mask that unleashed his wild side; Wesley Snipes killed vampires; and Christina Ricci met a friendly ghost named Casper. But as a new cycle of films began in the early years of the twenty-first century, the events of September 11, 2001, had an unmistakable influence on cinematic adaptations of comics.

"SOME MEN JUST WANT TO WATCH THE WORLD BURN": POST-9/11 CINEMA

Many writers view twenty-first-century comic book cinema as a forum for audiences to work through post-9/11

trauma, yet assessing the relationship between real-world events and fictional entertainment is not always easy. Chris Knowles argues in *Our Gods Wear Spandex: The Secret History of Comic Book Heroes*, for instance, that the box-office success of *Spider-Man* was due in part to the still-fresh memories of September 11, 2001, which he says "explains why the film packed the visceral punch it did. As we watch Spider-Man triumph over the forces of chaos and evil, in some sense the psychic damage done that day is repaired. And those primal fears still linger. Witness the success of the 2005 *Batman Begins*, which also featured similar acts of apocalyptic mayhem wreaked on Gotham City" (12). Knowles equates the success of a film like *Batman Begins* to the role played by post-9/11 trauma (i.e., "psychic damage"), rather than to the way it course-corrects the unpopular camp approach taken in the franchise's previous entry, *Batman and Robin*, or to its status as a prequel in which Bruce Wayne's journey toward heroism is finally traced or to director Christopher Nolan's auteurist traits.

As the film scholar David Bordwell notes, it's tempting to explain the rise of comic book movies through the notion of a cultural zeitgeist, with their success "read as taking the pulse of the public mood or the national unconscious" (23). As domestic concerns about terrorist attacks rose after September 11, 2001, superhero cinema

seemed to offer audiences visceral protection from violence and villains. To be sure, there are elements in many such films that drew on public fears of domestic terrorism, but to offer up the comic book movie as a healing, cathartic force for a nation's psychic damage is an oversimplification at best. Filmmakers (and, more importantly, film studios) usually don't make movies for therapeutic purposes. Movies are a product to be bought and sold, first and foremost. When great art happens to coincide with profitable entertainment, audiences and executives alike rejoice. But arguing that a comic book movie like *Spider-Man*'s primary role is a cathartic one is absurd. Audiences want to watch a man swing through the sky on a spiderweb. Any political resonance is just gravy on top of the visceral meat-and-potatoes thrills provided.

Bordwell similarly describes how "filmmakers opportunistically pluck out bits of cultural flotsam, stir it all together, and offer it up to see if we like the taste. It's in filmmakers' interests to push a lot of our buttons without worrying whether what comes out is a coherent cultural position" (25). Audiences seek visceral thrills, yes; when this happens to be packaged around political subtext, all the better for offering something that can be sold as more than mere escapism. So when Alfred Pennyworth tells Bruce Wayne, "Some men aren't looking for anything logical. They can't be bought, bullied, reasoned, or negotiated

with. Some men just want to watch the world burn," in *The Dark Knight*, such dialogue takes on the added weight of real-world terrorist attacks, even though its primary goal is furthering The Joker's cinematic characterization.

Perhaps *The Dark Knight* isn't quite the total product of post-9/11 malaise that some people might have you believe, even as it centers around The Joker's hospital-destroying anarchy (albeit within the relatively traditional pursue-and-capture story line embodied by the action genre). Looking at the source material itself, however, we find that comic books frequently took a darker, often politically driven turn over the past decade and a half. Marvel's 2008 *Secret Invasion* event saw numerous heroes replaced by the alien shape-shifter Skrulls, leading to rampant distrust and paranoia among the superhero community. This was immediately followed by a related event, *Dark Reign*, which saw the supervillain Norman Orborn (aka The Green Goblin) put in charge of the government's counterterrorism branch, S.H.E.I.L.D. Between 2008 and 2010, the mood was a dour one in the world of Marvel comics as a corrupt figure masqueraded as a public savior.

DC followed suit in 2013 with its *Forever Evil* event, in which heroes and villains united to stop a greater threat. The tone was again a bleak one as it explored the boundaries between good and evil, morality and depravity,

with Lex Luthor even stating, "Hope is meaningless now. Hope won't save the world" (Johns and Finch), in an allusion to the iconic posters of Barack Obama. In 2016, Marvel rewrote Captain America's past, making him a longtime sleeper-cell agent of Hydra (i.e., Marvel Comics' equivalent of Nazis). The 2017 event *Secret Empire* in turn connotes that the American public is willing to make sacrifices in the name of security: "We didn't know it then, but this was the moment it all ended. The moment we compromised everything we believed in—in the name of our fear" (Spencer and Acuna).

Clearly, the source material on which so many comic book movies are based has taken obvious pains to concoct political metaphors. We need not attribute the social or political meanings of these films to an indistinct cultural zeitgeist. The source material itself is already frequently politically minded, and while specific story lines are rarely adapted faithfully into films, it is still fair to say that the general tone of how comics creators have positioned their heroes in recent years has made its way onto the screen. "In my work, hiding in plain sight, is always how I feel about the world," says the comics writer Jimmy Palmiotti. "It would be impossible to avoid [politics] and expect the reader to be engaged," he argues (Herviou). The writer Scott Snyder concurs: "It's very hard to tune out these things that are hitting nerves all over the place.

... Every day there's something to get upset about, regardless of what side you're on" (Herviou).

Both comic books and the films adapted from them have tapped into social and political concerns over the past fifteen years, not in zeitgeist-like abstraction but as conscious metaphors. The recent success of comic book movies certainly parallels the United States' roles in Afghanistan and Iraq, as well as ongoing efforts against terrorist groups like the Taliban and ISIS. There has not been the same push to embed these military efforts into modern narratives for morale-building purposes in the way that 1940s films did, which is true of Hollywood cinema in general. Instead, comic book movies have used the ongoing public concerns surrounding terrorism to add the sense of social relevancy to their amazing and/ or uncanny characters and fantastic stories. Take *Captain America: Civil War*, for example, loosely based on the 2006–2007 miniseries *Civil War* pitting Captain America and his rogue group of allies against Iron Man's efforts at government registration for all superheroes. The book and the film are both at their core excuses to make superheroes fight each other. In previous decades, comic books would have hero battle hero because of some arbitrary (and quickly resolved) misunderstanding. Now that the trope has become a cliché, comics writers must devise more systematic ways of having heroes turn on

one another. Government registration serves nicely as a plot device around which conflict can be stirred and real-world political concerns channeled (see Costello; Scott).

Themes of war and protection permeate films like *300*, *300: Rise of an Empire* (2014), *Captain America: The Winter Solider, Iron Man 3* (2013), and *Wonder Woman*. Filmmakers regularly embed such films with patriotic or subversive discourses about the role of military conflict in society, turning action-oriented entertainment into vehicles for political commentary, whether subtle or overt. *Iron Man* opens with Tony Stark demonstrating his new missile system in Afghanistan, as he boasts, "They say that the best weapon is the one you never have to fire. I respectfully disagree. I prefer the weapon you only have to fire once. That's how Dad did it, that's how America does it, and it's worked out pretty well so far. I present to you the newest in Stark Industries' Freedom line. Find an excuse to let one of these off the chain, and I personally guarantee the bad guys won't ever want to come out of their caves." Despite the jingoistic rhetoric here, the film makes an obvious connection between "finding an excuse" to detonate the latest and greatest mother of all bombs and displays of military power in the name of freedom.

In turn, some comic books films offer metaphoric moments further undercutting such hawkish sentiments. *The Incredible Hulk* features scenes of General "Thunder-

bolt" Ross and his air-force unit attacking The Hulk with a battalion of tanks and planes, demonstrating the US armed forces in the attempt to stop the unstoppable. While the attack begins as a display of US military might, it quickly proves ineffective against something stronger than itself. Comic book movies frequently present their audiences with images and allegories of a political nature, whether it be foreign terrorists prompting wealthy American industrialists to don suits of armor, Axis spies battling caped crusaders, or domestic madmen who just want to watch the world burn. War—in the words of Edwin Starr—may be good for absolutely nothing, but it has fed comic book films for decades.

"AND FROM THE ASHES OF THEIR WORLD, WE'LL BUILD A BETTER ONE!": DYSTOPIAN POLITICS

Images of war frequently become mixed with themes of dystopia and anarchy in films like *Dredd*, *X-Men: Days of Future Past*, and *Suicide Squad*. Cities burn, and communities fall. Traditional lines between heroic actions and villainous ones fade away. In *X-Men: Apocalypse*, the title villain bellows ominously, "Everything they've built will fall! And from the ashes of their world, we'll build a better one!" As the United States' mood has shifted from the hope and optimism of Barack Obama's inauguration

to the umbrage and desire among some Americans for restoration that fueled Donald Trump's surprise election victory, the dystopian and antiestablishment themes of recent comic book movies have proven to be an uncanny precedent of modern political events. "I am born of death. I was there to spark and fan the flames of man's awakening, to spin the wheel of civilization. And when the forest would grow rank and needed clearing for new growth, I was there to set it ablaze"—thus spoke Apocalypse. Likewise, in *Avengers: Age of Ultron*, the title supervillain declares, "I was designed to save the world. People would look to the sky and see hope. . . . I'll take that from them first." Just as democracy dies in darkness, so too does hope begin to fade when a populace can be made to feel fear.

Describing Trump's first general-election advertisement, the journalist Greg Sargent notes that it "is filled with precisely the same sort of dark, dystopian themes and content—and even some of the same sort of grainy, dark footage depicting illegal immigrants as invaders— that marked one of the first ads he ran during the GOP primaries." Such "dark" images pervade comic book films of recent years, from the murky visuals and ethical dilemmas of *Watchmen*, *The Dark Knight Rises* (2012), and *Batman v. Superman: Dawn of Justice* to the bleak tone and unblinking violence of *Suicide Squad* and *Logan* (2017). Much as Trump ran his campaign by appealing to feelings

of inefficacy and provincialism, *Batman v. Superman* finds Bruce Wayne's butler, Alfred Pennyworth, describing how "everything's changed. Men fall from the sky, gods hurl thunderbolts, innocents die. That's how it starts, sir. The fever, the rage, the feeling of powerlessness that turns good men cruel."

In one of the presidential candidates' televised debates, Hillary Clinton said that Trump has "a dark and dangerous vision of America" (19 Oct. 2016). The day before the 2016 election, Tessa Berenson's *Time* magazine article further echoed, "To hear Donald Trump tell it, Tuesday's results will either save or ruin the country. Americans will emerge from Election Day ascendant with a strong new leader who heeds their cries, or they will plunge into a dystopian future of hopelessness and violence." Clearly, each candidate believed that the United States was headed down a dark path if the other won. This "dark" rhetoric abounds in recent comic book movies: In *Watchmen*, the antihero vigilante Rorschach describes how "once a man has seen society's black underbelly, he can never turn his back on it. Never pretend . . . that it doesn't exist." The villainous Bane in *The Dark Knight Rises* tells Batman that he "merely adopted the dark": "I was born in it, molded by it." In *Amazing Spider-Man 2*, Gwen Stacy speaks of how "there will be dark days ahead of us" but that "we have to be greater than what we suffer." In *Suicide Squad*, the

assassin known as Deadshot similarly states, "You know the dark places too. Don't act like you don't." The latter film assembles "a team of some very bad people," who their government handler, Amanda Waller, thinks "can do some good." Much like the way the moral lines between heroism and villainy are blurred in the film, the 2016 election cast its players in an ever-shifting balance between valor and horror and between tragedy and farce.

As the newly elected president was sworn in on January 20, 2017, the *Washington Post* reported that Democrats roundly criticized Trump's inauguration speech "as 'dark' and 'divisive.'" Congressman Gerry Connolly called it "a dark, dystopian, defiant inauguration speech," while congressman Adam Schiff described it as a "dark portrait of America" (Stevenson). The fallout of Trump firing FBI director James Comey led one White House aide to describe the mood in the Oval Office as "chaotically dark" (Liptak et al.). When the mayor of Charlottesville, Virginia, criticized the president for blaming "many sides" rather than specifically condemning the violence by white supremacists in that town on August 14, 2017, he offered that "people will react to the darkness with a whole lot more light" (Watkins).

Some people might dismiss such views as mere partisan grumblings, yet the strange fact that some of Trump's speech directly echoes the words of a comic book

supervillain is surely enough to stir pause and reevaluation: "Today, we are not merely transferring power from one administration to another, or from one party to another—but we are transferring power from Washington, DC, and giving it back to you, the people," said Trump during his inauguration. His words are eerily similar to those of Bane five years earlier in *The Dark Knight Rises*: "We take Gotham from the corrupt! The rich! The oppressors of generations who have kept you down with myths of opportunity, and we give it back to you, the people" (Stevenson).

Bane and Trump each cast themselves as revolutionary figures offering restitution for a general public presumed to have grown weary of the status quo. Lex Luthor was elected president of the United States for similar reasons in the pages of DC's comics in 2001, only to fall from grace two years later when his attempt to frame Superman was exposed. He later gained an orange power ring similar to that of Green Lantern, except that it drew strength from Luthor's narcissistic desires and innate greed. Norman Osborn's rise to power in Marvel's *Dark Reign* story line (and his subsequent team of villains-posing-as-heroes in *Dark Avengers*) was also undone by his own egotism (along with mental instability, as his Green Goblin personality eventually resurfaced).

• • •

The dystopian themes and bleak tone of many recent comic book films are now regularly echoed in the news. Perhaps most troubling is the real-world paralleling of how both the print and screen versions of *Watchmen* depict the Doomsday Clock inching closer to the midnight of nuclear annihilation. The *Bulletin of the Atomic Scientists* moved their own Doomsday Clock forward to two and a half minutes before midnight shortly after Trump's inauguration, the closest it has been since the dawn of the Cold War in the early 1950s. Comics, and the films adapted from them, frequently depict the dangers of allowing evil to triumph. Oscar Wilde famously noted that "Life imitates Art far more than Art imitates Life," but the lines between them seem increasingly blurred as modern politics echo the dystopian themes of recent comic book movies.

4

STYLE

The term "comic book movie" often describes not just films of a certain genre but a distinctive style as well—not just what a film is about but how it looks. On the surface, this presumably means that a film resembles a comic book: bright colors and vibrant costumes; extravagant sound effects (like "Thwip," "Bamf," and "Snikt"); computer-generated imagery allowing character movements to bend the laws of physics. Watching comic book movies, by this definition, is somehow akin to reading actual comics, much like eating homemade kale chips is somehow akin to eating potato chips. Both comparisons are misleading, of course; minor similarities abound, but each is an inherently unique experience with its own specific pleasures. As Michael Cohen observes, "Describing a relationship between the mechanisms of cinema and comics is a more complicated proposition than attaining an ornate and colorful *mise-en-scène*, or costume design, or similarly developing a 'cartooning' effect. Although

cinema and comics use images in sequence, both utilize different mechanisms of narrative communication" (30).

But just as some critics use the "comic book movie" label as a way of signaling an ultimately frivolous story line / genre (as chapter 1's review of *Doctor Strange* shows us), the term also gets applied to films that are *not* based on comics as a way of describing their visual imagery. A *Deadline Hollywood* article on cinematic gun violence notes that movies usually secure "a softer rating when incidents of gun violence are bloodless or done in an unrealistic, comic-book style" (Ceiply). Similarly, a review of *Guardians of the Galaxy Vol. 2* (2017) describes how the series's first film "barely felt like a comic book movie at all," resembling a "grungy *Star Wars* episode" instead (Owen). Both cases imply that comic book movies offer a visual style rooted in colorful abstraction rather than gritty realism. They seemingly offer fantastic images rather than everyday ones, strange sights in place of familiar ones—such as the kaleidoscopic city streets of *Doctor Strange*, which literally twist and turn throughout the film's finale.

So when a film seeks to replicate the visual style of a comic book, it essentially draws on the formal qualities of another medium. In media theory, the process of using one medium's formal conventions within another is known as "remediation," or "the representation of one

medium in another" (Bolter and Grusin 45). Many adaptations of novels in the early years of sound cinema, for instance, would begin with a hand flipping the pages of the book during the opening credits, suggesting that as viewers, we are vicariously reading the original work by watching the film. Remediation is not the same thing as adaptation, however. Instead of simply telling an existing story from one medium in a different one, remediated imagery uses the actual formal qualities of other media.

In *Panel to the Screen: Style, American Film, and Comic Books during the Blockbuster Era*, Drew Morton examines the "stylistic remediation" of comic book cinema, whereby "a style can migrate across different media forms." Style, he says, "can be as much of a commodity as the superheroes" themselves (17). Early comic book and comic strip movie producers knew this, using the same fonts as the source material, embedding comics panels and pages within the opening credits, and regularly showing the main character/actor breaking through those pages to appear in the flesh (or its celluloid equivalent).[1] Marvel still applies this stylistic remediation in its company logo greeting audiences as each film begins, with a rapid turnover of comics imagery suggesting the flipping of pages.

Such practices are meant to lend authenticity to the adapted version by remediating visual aspects of the

original. *American Splendor* won a special prize at the Cannes Film Festival for its creative use of imagery from Harvey Pekar's underground comic book of the same name. Director Ang Lee's *Hulk* wasn't met with nearly as much enthusiasm, though, in its arrangement of multiple frames to suggest comics panels. The *Los Angeles Times* critic Manohla Dargis complained, "Lee even dices his mise-en-scene into pieces to replicate the paneled look of comic books. However nifty, his Cubist gambit fails to capture the graphic tension that makes great comic-book art jump off the page and great pop movies jump off the screen with pow, zap and wow!" ("Taming"). With a playful "zap" and a "pow," Dargis dismisses Lee's film while drawing on the type of rhetoric that has led to using the "comic book movie" term as a stylistic indicator.

But the bigger issue raised here is whether audiences will accept, and studios allow, distinctive displays of personal style from their directors. As comic book movies began to consistently dominate the box office and the Marvel Cinematic Universe changed how Hollywood approached film franchises, fewer attempts are being made to replicate the panels, gutters, word balloons, onomatopoeic sound effects, and other formal traits of the comics medium. Individual style is increasingly frowned on in favor of uniformity. Each studio has achieved a relatively constant look (with some notable exceptions)

to its franchises, be it Marvel/Disney's Avengers-related titles, Twentieth Century Fox's X-Men films or Warner Brothers' Justice League entries. These patterns are nothing new, of course, since comic book movies were held to a standardized style throughout Hollywood's classical era.

YOU WILL BELIEVE A MAN-ON-WIRES/DUMMY/ ANIMATED CHARACTER/CGI-MAN CAN FLY

When the first film serials began adapting comic book heroes in the early 1940s, the production methods for making cliffhangers were already well established. Little room existed for unique stylistic flourishes, since the most successful serial directors were those who could finish a film quickly and without going over budget. Made by B-unit producers at smaller Hollywood studios like Universal and Columbia and at cost-conscious Poverty Row companies like Republic Pictures, serials were strictly low-budget filmmaking in this era. Under such circumstances, the special effects required to make caped heroes fly, punch through walls, and perform other fantastic feats posed not only technological challenges but budgetary ones too.

Audiences watched the first superheroes fly across the screen in 1941, in Republic's *Adventures of Captain Marvel*

serial and later in animated shorts starring Superman. While animation offered one solution to the problem of cinematic flight, live-action filmmaking demanded a different approach, especially at one of Hollywood's smallest studios. The producers of *Captain Marvel* opted for a dummy dressed like the title hero, propelled through the air on a wire. The effect was achieved by having the rugged actor Tom Tyler leap into the air (usually via an unseen springboard), followed by a different shot of the dummy sailing through the sky. Tyler then landed back on the ground in a subsequent shot to complete the illusion of flight. Animation and wire-guided dummies were both ways to represent the human body in achieving superhuman feats using noncorporeal forms. The bodies in flight are clearly not alive, but the audience takes pleasure in the movement of characters who remained static on comics pages, which could only suggest motion. Viewers project the image of Tyler / Captain Marvel onto the flying dummy, just as they imagine the hero flying as they read the comics.

Awareness of the techniques used to make a man fly in the film didn't stop the enjoyment of the result, much as modern viewers enjoy the action scenes in recent comic book movies despite the at times obviously computer-generated bodies on display. In the essay "Why I Hate Superhero Movies," Scott Bukatman notes that comic

book movies "depend to a large extent on computer-generated animated bodies to replicate the bodies in the comics (it's been joked, with some validity, that Hollywood has only now become capable of producing images like those Jack Kirby turned out forty years ago)" (118). The "central problem" of modern superhero films "involves the integration of live action and computer-generated imagery," which risks creating "vaguely rubberoid [looking] action figures harmlessly bouncing each other around the space . . . [with] nothing at stake" (119–120), much as the producers of Captain Marvel had to figure out how to match Tyler's body with that of a dummy. Today's audiences typically applaud the effects and accept the artifice of CGI superheroes, much as they did in the 1940s with wooden and animated ones.

The struggle between budget and style in adapting comics to the screen was also a major concern for Sam Katzman, one of the most prominent producers of B films and serials in the 1940s. Known for his frugal approach to filmmaking, Katzman shot test footage for his 1948 *Superman* serial with the actor Kirk Alyn dangling from wires. After deeming the effect unsuitable for the serial, Katzman then used the approach (and presumably the same test footage) in the 1950 sequel *Atom Man vs. Superman*.[2] For the first serial's flying scenes, Katzman used animation—much like the way Tyler was replaced by a

dummy, Alyn was replaced by a drawn doppelganger as he leapt into the air. As with *Captain Marvel*, the effect was crude but charming, and audiences accepted it, even if they didn't fully believe it to be real.

Superman and the Mole Men (1952) also used wires and springboards to make the Man of Steel fly, in the cinematic precursor to the *Adventures of Superman* television series. Comic book heroes were largely limited to the small screen for most of the 1950s, 1960s, and 1970s. In 1966, three programs debuted that set the tone for how comic book film style would be understood in the decades that followed: the live-action *Batman* series starring Adam West and Burt Ward, an animated *Spider-Man* series, and a show that used actual art from various Marvel titles as the basis of its animation in *Marvel Super Heroes* (featuring rotating episodes starring Captain America, The Hulk, Iron Man, Sub-Mariner, and Thor). Each featured colorful imagery inspired by the original source material. *Spider-Man* used such techniques as speed lines and jagged starbursts during moments of action; *Marvel Super Heroes* featured original artwork by Jack Kirby and Don Heck; and *Batman*'s animated opening was in the general style of the artists Jerry Robinson and Dick Sprang. *Batman* is also famous for its use of onomatopoeia during fight scenes, as fisticuffs are interspersed with title cards of the "pow/zap" variety.

Batman's camp aesthetic and the overall Pop Art sensibilities of these three series have dominated the way critics and the public approached comics adaptations in recent decades,[3] with this pow/zap rhetoric dominating many film reviews and articles. The comics scholar Mel Gibson analyzes one press article titled "Wham! Bam! The X-Men Are Here" in relation to the release of *X-Men*, noting a pattern in which comics are positioned at the bottom of a high-/low-culture divide (109). With onomatopoeic fight sounds ("Bam!") consistently used to describe comics adaptations since the mid-1960s, it's little wonder that critics still look at a film like *Doctor Strange* and believe that the actors make it feel classier than it should. But the tone and style being spurned really stems from the legacy of how television used comic books as source material, not because of the images presented by the films themselves. The X-Men and Spider-Man movies contain nary a "wham," "bam," or "pow" in the 1966 sense, generally treating their stories and characters with more earnest tactics rather than a camp flair.

YOU WILL BELIEVE AN AUTEUR DIRECTOR CAN MAKE A MAN FLY

Superheroes continued branching out into live-action television throughout the 1970s with *Wonder Woman*

(1974 TV movie; 1975–1979 series), *Spider-Man* (1977 TV movie; 1977–1979 series), *The Incredible Hulk* (1978–1982 series), *Dr. Strange* (1978 TV movie), and *Captain America* (two 1979 TV movies). So by the time *Superman* arrived in theaters in December 1978, audience expectations for how a superhero should look on-screen were conditioned by a series of wham-bam cartoons and relatively lower-budget television programming. *Superman*'s tagline—"You will believe a man can fly"—invokes not only the mythic relevance of this imagery (that a flying man is culturally or spiritually important) but also that audiences will believe in the film's special effects. In *Matters of Gravity: Special Effects and Supermen in the 20th Century*, Scott Bukatman describes how "special effects emphasize real time, shared space, perceptual activity, kinesthetic sensation, haptic engagement, and an emphatic sense of wonder" (115–116). The best effects, then, engage multiple senses—we *feel* them with our body (like a roller-coaster ride, as the cliché goes) just as much as we see and hear them, allowing us to buy into these special effects as believable.

This sense of "wonder" described by Bukatman involves that moment when we accept the possibility of the fantastic events shown on-screen—that a hero can fly, swing, or leap through the air, climb walls like a spider, or catch bullets bare-handed. We know logically that

such things aren't humanly possible, but we still delight in images suggesting otherwise—for reasons tied to the role of myth but also because as human beings, we crave spectacular sights that we've never seen before. If a special effect can successfully "destabilize us," Bukatman argues, allowing the audience to cross over into unfamiliar modes of seeing and experiencing the world (like the stop-motion animation of Ray Harryhausen or the bullet time of *The Matrix* [1999], for instance), "then it should be acknowledged that we welcome the effect. We are moved away from the mundane, away from the ordinary—in some sense we are moved away from the narrative and into the pleasures of the spectacle" (*Matters* 116). We *want* to believe in the reality of the effect, to feel like what we are seeing isn't artificially constructed but instead entirely natural—that the fantastic is truly possible.

But even if we can suspend our disbelief—if only for a few moments—that a man can fly or a woman can stop bullets, like a magician's best tricks, we soon wonder how it was done. We delight in the spectacle of *Captain Marvel*'s flying dummy, the animated doppelganger in the *Superman* serial, and the globe-spinning strength of Christopher Reeve in the 1978 film, even though the rational mind knows such feats are impossible. Yet the best comic book films make us believe, however briefly, that Superman can fly, Wolverine can pop his metallic

claws, or Deadpool can survive being regularly maimed and mutilated.

Many superhero movies languished in development-hell for years in large part because it would have proved too difficult—and expensive—to create believable representations of the characters. After the screenwriter Sam Hamm had success with *Batman*, he sold a script for *Watchmen* to Twentieth Century Fox, with Joel Silver set to produce and Terry Gilliam to direct.

An *Iron Man* movie was also in the works beginning in 1990, with Tom Cruise attached to play Tony Stark ("Warden"). After mastering the art of morphing in *Terminator 2* (1991), James Cameron sought to make a Spider-Man film throughout much of the 1990s (Keegan). None of these projects emerged until much later, of course, and with different creators. The technology required to make an armored Avenger, web slinger, or *Watchmen*'s nuclear-powered character, Doctor Manhattan, appear convincing on-screen just wasn't ready yet. This explains why comic book films of the 1980s and 1990s regularly featured heroes with no superpowers, like *Batman*, *The Punisher* (1989), *The Rocketeer*, *Timecop*, *Tank Girl* (1995), *Judge Dredd*, and *Steel*. It also sheds light on why Marvel superhero films of this period were strictly B-film fare, namely, *Captain America* and the Roger Corman–produced *The Fantastic Four* (1994), since the major studios weren't

comfortable mounting such efforts (lest spending more money result in equally low-budget-looking effects).

As much as audiences believed Superman could really fly in Richard Donner's 1978 film and his uncredited work in *Superman II*, later sequels proved increasingly unconvincing. As an auteur director who thrived in numerous genres, Donner regularly explored themes of heroism, morality, masculinity, and coming of age in the horror movie *The Omen* (1976), the adventure film *The Goonies* (1985), the fantasy effort *Ladyhawke* (1985), the action movie *Lethal Weapon* (1987) and its sequels, the Christmas comedy *Scrooged* (1988), the family drama *Radio Flyer* (1992), and the western *Maverick* (1994). Donner clashed with the producers Ilya and Alexander Salkind while directing *Superman* and was replaced before he could finish *Superman II* by Richard Lester (who made 1973's *The Three Musketeers* and 1974's *The Four Musketeers* for the Salkinds).[4] *Superman III* (1983) and *Superman IV: The Quest for Peace* are less well remembered than the series's earlier entries because their directors, Lester and Sidney J. Furie, respectively, couldn't match Donner's distinctive style and genuine tone, as the last two sequels slid at times toward self-parody.

While the 1980s saw relatively few comic book films achieve lasting fame, an intriguing pattern emerges when comparing adaptations from both this decade and the

early 1990s to those of recent years. While many comic book movies from this earlier period are visually distinctive and display traits of auteur directors, the Marvel Cinematic Universe typically favors a uniform look in which individual style is downplayed. Auteurist style remained more like a rule than an exception throughout the 1980s and much of the 1990s. The horror icon Wes Craven's *Swamp Thing* uses many tropes of the slasher film throughout, even though it isn't a horror movie in the strictest sense. In one scene, a man appears to peel the skin off from his face, only to be revealed that it is a prosthetic mask. In another, our protagonist is set ablaze and runs screaming into the swamp, echoing later shots of the hideously disfigured Freddy Krueger being set on fire in Craven's *A Nightmare on Elm Street* (1984). George Romero brought the horror stylings of *Dawn of the Dead* (1978) and *Martin* (1978) to *Creepshow*, a film based on the infamous 1950s EC horror comics like *Tales from the Crypt*, *The Vault of Horror*, and *Haunt of Fear*. *Creepshow* showcased Romero's unique blend of savage horror and dark humor.

Howard the Duck saw George Lucas wed his experience in big-budget blockbuster aesthetics to a steady dose of mid-1980s new-wave stylings in his much-hyped role as executive producer. The film saw a duck-out-of-water named Howard take his "first step into a larger world" (as per Luke Skywalker) after suddenly being transported to

Earth from Duckworld. A few years later, Tim Burton's *Batman* and *Batman Returns* featured his trademark blend of societal misfits and German expressionist-inspired visuals he recently explored in *Beetlejuice* (1988).

Throughout much of the 1990s, few comic book films looked alike. The vibrant color palette of *Dick Tracy* was unlike the nostalgic sheen of *The Rocketeer*, the dark designs of *The Crow*, the madcap excess of *The Mask*, or the dystopian dustiness of *Tank Girl*. A few years later, the crimson hues of the R-rated *Blade* and the pastiche of *Mystery Men*'s superhero satire were similarly unique from earlier offerings.

Blade's success allowed Twentieth Century Fox to confidently target *X-Men* to a relatively older audience after the juvenile tone of *Batman and Robin* failed at the box office. The strategy saw *X-Men* become one of the year's top-ten highest-grossing films, launching a long-running franchise. *Spider-Man* soon followed and easily became the top-earning film of 2002, thanks in part to director Sam Raimi's track record of reinventing various genre tropes (such as the horror film in 1981's *The Evil Dead* and 1987's *Evil Dead II*, fantasy in 1992's *Army of Darkness*, and the western in 1995's *The Quick and the Dead*). Like his earlier film, *Spider-Man* and *Spider-Man 2* included frenetic tracking shots, claustrophobic point-of-view shots, and a strategic use of humor to ease escalating tension.

As the twenty-first century began, comic book movies seemed like a realm in which acclaimed directors could bring new ideas to familiar comics characters. Ang Lee was hired to direct *Hulk* after the international success of *Crouching Tiger, Hidden Dragon* (2000), while Christopher Nolan was brought on to reinvigorate the Batman franchise after his success with crime films like *Memento* (2000) and *Insomnia* (2002). But as the genre developed, fewer and fewer directors found room to apply their own filmmaking style.

YOU WILL BELIEVE A FRANCHISE CAN FLY

Both *X-Men* and *Spider-Man* proved to Hollywood that special-effects technologies could capably render superhero bodies in defiance of gravity, physics, and human physiology. Together, they also proved that audiences were eager to watch mythic heroes do things with their bodies that stretch beyond the limits of mortal men and woman. Films like *Daredevil* and *Fantastic Four* (2005) followed, which were profitable but not well remembered by critics or fans. Seemingly, the thrill of watching a blind man fight crime, a scientist stretching his rubberized limbs, or a flame-engulfed teenager fly was enough to sell tickets and spawn sequels (2005's *Elektra* and 2007's *Fantastic Four: Rise of the Silver Surfer*).

So when Universal released *Hulk* in 2003, there was incredible anticipation for the Green Goliath's cinematic debut. If the state of then-current special effects could believably allow Tobey Maguire to sling webs across Manhattan as Peter Parker, then surely Bruce Banner's gamma-radiated, tank-smashing tantrums could work. But Ang Lee's *Hulk* was considered upon its release an all-around flop by most fans and critics and at the box office, although some scholars (myself included) see it as an underrated experiment in remediating the imagery of comic book panels on-screen (see, e.g., Jeffries). Lee, known for such thoughtful films as *Eat, Drink, Man, Woman* (1994), *The Ice Storm* (1997), *Brokeback Mountain* (2005), and *Life of Pi* (2012), emphasizes themes of memory, family, and childhood trauma in *Hulk*. The film's highly artistic style features extensive use of multiple split-screen panels, along with montage sequences that combine Banner's memories with biological imagery in depicting his transformation into the green monster. Lee's film is a prime example of an auteur director making a comic book movie before the genre was subject to the corporate needs of interconnected franchises.

There is much more individual style in Lee's *Hulk*, for instance, than in the follow-up *The Incredible Hulk* by Louis Leterrier. While his action vehicle *The Transporter* and its 2005 sequel offered revved-up thrills, *The Incredible*

Hulk more resembles the empty spectacle of Leterrier's *Clash of the Titans* (2010)—somewhat satisfying in the moment but too safe to be noteworthy. While *Iron Man* is now considered a beloved classic, Jon Favreau's Marvel films are bookended by two forgettable sci-fi films, *Zathura: A Space Adventure* (2005) and *Cowboys & Aliens* (2011). Kenneth Branagh's *Thor* displays little evidence of his earlier work adapting Shakespeare. For *Captain America: The First Avenger*, Marvel hired Joe Johnston for his experience on such effects-heavy genre films as *The Wolf Man* (2010) and *Jurassic Park III* (2003), choosing reliability over artistry. That Favreau is now specializing in CGI-heavy Disney remakes like *The Jungle Book* (2016) and *The Lion King* (2019), while Johnston has been hired to helm an upcoming *Chronicles of Narnia* sequel, demonstrates just how director-proof most of Marvel's movies really are. Clearly, a steady hand and a studio-friendly attitude are more important to Marvel than is a director's signature vision of any particular character.

This pattern cuts across studios—for every stylistic surprise like *Blade II*, *Scott Pilgrim vs. the World*, or *Kingsman: The Secret Service*, there's a slew of visually indistinct films like *X-Men Origins: Wolverine* (2009), *Iron Man 2*, *Thor: The Dark World* (2013), *The Amazing Spider-Man 2*, and *X-Men: Apocalypse*. Even memorable films like *Ant-Man* and *Deadpool* are better remembered for their humor than

for their directors. *Ant-Man* had been in development for years with *Scott Pilgrim* director Edgar Wright, who sought to bring the irreverence of *Sean of the Dead* (2004) and *Hot Fuzz* (2007) to the Marvel Cinematic Universe. Instead, creative differences led Marvel to replace Wright with Peyton Reed, who found success with pleasant comedies like *Bring It On* (2000) and *Down with Love* (2003) before making such mediocre star vehicles as *The Break-Up* (2006) with Vince Vaughn and *Yes Man* (2008) starring Jim Carrey. *Ant-Man* emerged as a capable entry into Marvel's screen playground, thanks in large part to what still remained from Wright's original screenplay.

DC Comics has generally shown more trust in its directors, allowing Christopher Nolan to reinvent Batman, Pitof to ruin Catwoman, and Zack Snyder to build the Justice League across numerous films. While David Ayer's *Suicide Squad* retained the same dark tone as Snyder's *Batman v. Superman: Dawn of Justice*, Patti Jenkins's *Wonder Woman* featured enough of a unique visual palette to give hope that future DC films won't be subject to the same level of visual similarity (what was called a "house style" in the studio system era of classical Hollywood) as Marvel seems to demand of its directors.

In the end, of course, the characters and the stories are why audiences go to comic book movies, not the directors. This is why Disney/Marvel, Twentieth Century Fox,

Columbia Pictures, and other studios are increasingly hiring less established directors who have recently made relatively successful independent or foreign films, like Gavin Hood (*Tsotsi* [2005], *X-Men Origins: Wolverine*), Marc Webb (*500 Days of Summer* [2009], *The Amazing Spider-Man*), Josh Trank (*Chronicle* [2012], *Fantastic Four* [2015]), Taika Waititi (*What We Do in the Shadows* [2014], *Thor: Ragnarok* [2017]), Jon Watts (*Cop Car* [2015], *Spider-Man: Homecoming* [2017]), and the directing team of Anna Boden and Ryan Fleck (*Mississippi Grind* [2015], *Captain Marvel*).

The primary goal with this strategy is to hire directors who can draw strong performances from their actors on a lower budget and to avoid the type of conflicts (and overspending) that the producer Ilya Salkind had with Richard Donner on the set of *Superman*. The comic book movie in turn becomes director-proof, as the studio enjoys the kind of larger control demanded by the needs of an interconnected film franchise as well as transmedia extensions such as related television shows like *Marvel's Agents of S.H.I.E.L.D.*, video games, and so on. Few people saw *Guardians of the Galaxy* primarily because of director James Gunn's work on *Super* (2010) but rather to see a talking raccoon with a gun fight alongside a sentient tree creature in outer space. Gunn's work on the film was stellar, certainly, but it wasn't his name that sold tickets.[5]

Movies are now just as likely to be based on toys, board games, video games, and comic books as they are novels and plays. Perhaps the rise of new genre descriptors like "comic book movie" and "video game movie" is a symptom of modern Hollywood's intensifying push toward pre-sold audiences. If a film isn't based on a familiar property that viewers don't already recognize—be it a popular novel, a comic book character, or a toy line like Lego—the studio usually must do more to successfully market an unknown concept/story, unless a popular star or director is involved. But if the audience will pay to see a film because they already know its characters, the need for established directors, and even actors, diminishes. Few people knew Chris Hemsworth's work aside from a brief appearance in *Star Trek* (2009) before he was cast as *Thor*, just as few people knew who Tom Holland was before he became Peter Parker in *Spider-Man: Homecoming*.

The comics industry has long been seen by the people working within it as a testing ground for other media. The comics creator Frank Miller (*The Dark Knight Returns*, *Sin City*, *300*) recounts being told as much by one company:

> Comics is a Research and Development branch, as was said to me by one of my publishers. . . . See, in Hollywood the stakes are very, very high, and there are a great number of people involved. The studios are spending a hundred

million dollars on something, and that raises the tension. So they have a harder time generating and seeing through a really fresh and individual idea. It's just human nature when the stakes are that high.

So when they see all this stuff popping out of comics with all of this outrageous variety, they want it. (Eisner and Miller 316–317)

Similarly, the Marvel marketing executive Paul Gitter said in 2010, "The big play here is that Marvel is really looking at our films more as brands and less as films. The goal here is to become more of a household name similar to Procter & Gamble and Johnson & Johnson. We want Marvel to take a much greater position in the minds of the consumer when they are thinking about our properties." In describing the connected role of each film in the Marvel Cinematic Universe, Gitter described how "you're going to build momentum by using each of the preceding brands almost as a marketing vehicle" for upcoming films (Steinberg).

The phenomenal success of this approach changed the way Hollywood does business, with each studio now clamoring for a universe of its own. Warner Brothers' has both the DC Extended Universe and the growing Lego film franchise. Universal Pictures' Dark Universe features classic monsters in such films as *The Mummy* (2017). The

Hasbro Cinematic Universe has grown from numerous *Transformers* and *G.I. Joe* films to upcoming projects based on such toy lines as the Micronauts, M.A.S.K., and ROM. The latter universe is being helmed by the power team of the acclaimed novelist Michael Chabon, the award-winning comics writer Brian K. Vaughan, and the Oscar-winning screenwriter Akiva Goldsman (Kit). As Derek Johnson writes in *Media Franchising: Creative License and Collaboration in the Culture Industries*, film studios "have recently turned to co-branding strategies to push the logic of franchising forward," with a new emphasis on existing media properties rather than original stories, "with trademarks shared, commingled, and exchanged on an even greater scale" (233).

Several comic book sayings seem appropriate here in considering the growing role of the comics industry to Hollywood as it assembles its Avengers-like franchises: Studio executives are a superstitious, cowardly lot. With great studio power, there must also come great responsibility. Don't make audiences angry . . . you wouldn't like us when we're angry. But despite what may follow as movies become brands and intermingled franchises flourish, perhaps Nick Fury put it best in *The Avengers*: "I still believe in heroes."

ACKNOWLEDGMENTS

My deepest thanks to my wife, Erin, and our kids, Audrey and Ewan (when you're older, you can watch all of these movies, I promise!). My gratitude once again to Leslie Mitchner, Lisa Boyajian Banning, and their colleagues at Rutgers University Press, as well as to series editors Wheeler Winston Dixon and Audrey Foster. Thanks to Ian Gordon for his valuable reader review comments, as well as to the usual crew of comics studies folks who are too numerous to name!

NOTES

1. GENRE

1. Aircel Comics published the three-issue series *The Men in Black* in 1990, with a second series released in 1991 after the company was acquired by Malibu Comics (which was itself purchased by Marvel Comics in 1994).

2. Despite *Ghost World*'s seeming incongruity with superhero films, Martin Flanagan usefully observes that the film depicts "the emotional subjectivities and struggles for selfhood of their protagonists" that comic book movies like *Spider-Man* frequently embody (145). That both *Ghost World* and films like *Spider-Man* are about transitioning from adolescence makes the comparison even more striking.

2. MYTH

1. See, for instance, Reynolds. This notion has been disputed by Noah Berlatsky, however.

2. Ian Gordon explores the mythological role of Superman in chapter 1 of *Superman*.

3. See, for instance, Holifield 38–40.

4. David Bordwell and Kristin Thompson discuss the role of origins within comic book movies further, describing

how the term "origin stories" emerged from mythol-
ogy scholars using it "to refer to various ethnic groups'
accounts of the origin of the world. . . . Then the term
got taken up in discussions of comic books" to describe
a much-smaller-scale application of the "origin story" to
specific superheroes (153).

3. POLITICS

1. See chapter 3 of my previous book *Movie Comics* for a
 more detailed analysis of the serial's adaptive strategies
 and the role of fidelity criticism therein. While many fans
 hate the film, decrying the cheap-looking costumes and
 lack of a distinctive Batmobile, the serial's low-budget
 production methods placed limits on its design (and
 automobile) expenses.

4. STYLE

1. For further analysis of these techniques in the classical
 Hollywood era, see Davis 14–19.
2. Paul Levitz notes that "the wires were too conspicuous"
 in Katzman's test footage (351).
3. For a thorough overview of the role of camp in the series,
 see Yockey.
4. For a detailed account of the production history of *Super-
 man* (1978) and its sequels, see Rossen.
5. Bradley Cooper's and Vin Diesel's voice work as Rocket
 and Groot were also strong in *Guardians of the Galaxy*,
 of course, but the computer-generated bodies of these
 unique characters were the main appeal.

FURTHER READING

Arnuado, Marco. *The Myth of the Superhero*. Baltimore: John
 Hopkins UP, 2013.
Brooker, Will. *Batman Unmasked: Analyzing a Cultural Icon*.
 New York: Bloomsbury, 2001.
———. *Hunting the Dark Knight: Twenty-First Century*
 Batman. New York: I. B. Tauris, 2012.
Brown, Jeffrey A. *The Modern Superhero in Film and Tele-
 vision: Popular Genre and American Culture*. New York:
 Routledge, 2016.
Bucciferro, Claudia. *The X-Men Films: A Cultural Analysis*.
 Lanham, MD: Rowman and Littlefield, 2016.
Burke, Liam. *The Comic Book Film Adaptation: Exploring
 Modern Hollywood's Leading Genre*. Jackson: U of Missis-
 sippi P, 2016.
Davis, Blair. "Beyond Watchmen." *Cinema Journal* 56.2
 (2017): 114–119.
———. *Movie Comics: Page to Screen / Screen to Page*. New
 Brunswick, NJ: Rutgers UP, 2017.
Fingeroth, Danny. *Disguised as Clark Kent: Jews, Comics, and
 the Creation of the Superhero*. New York: Continuum, 2007.
Gilmore, James, and Matthias Stork. *Superhero Synergies:
 Comic Book Characters Go Digital*. Lanham, MD: Row-
 man and Littlefield, 2014.

Gordon, Ian. *Superman: The Persistence of an American Icon.* New Brunswick, NJ: Rutgers UP, 2017.

Gordon, Ian, Mark Jancovich, and Matthew P. McCallister, eds. *Film and Comic Books.* Jackson: U of Mississippi P, 2007.

Hatfield, Charles, Jeet Heer, and Kent Worcester. *The Superhero Reader.* Jackson: U of Mississippi P, 2013.

Jeffries, Dru. *Comic Book Film Style: Cinema at 24 Panels per Second.* Austin: U of Texas P, 2017.

Jones, Gerard. *Men of Tomorrow: Geeks, Gangsters, and the Birth of the Comic Book.* New York: Basic Books, 2005.

Lopes, Paul. *Demanding Respect: The Evolution of the American Comic Book.* Philadelphia: Temple UP, 2009.

McEniry, Matthew J., Robert Moses Peaslee, and Robert J. Weiner, eds. *Marvel Comics Into Film: Essays on Adaptations Since the 1940s.* Jefferson, NC: McFarland, 2016.

Morrison, Grant. *Supergods: What Masked Vigilantes, Miraculous Mutants, and a Sun God from Smallville Can Teach Us about Being Human.* New York: Spiegel and Grau, 2012.

Morton, Drew. *Panel to the Screen: Style, American Films, and Comic Books during the Blockbuster Era.* Jackson: U of Mississippi P, 2016.

Naremore, James. *Film Adaptation.* New Brunswick, NJ: Rutgers UP, 2000.

Saunders, Ben. *Do the Gods Wear Capes? Spirituality, Fantasy and Superheroes.* New York: Bloomsbury, 2011.

Scott, Suzanne. "Fangirls in Refrigerators: The Politics of (In)Visibility in Comic Book Culture." *Transformative Works and Cultures* 13 (2012).

Taylor, Aaron. "The Continuing Adventures of the 'Inherently Unfilmable' Film: Zach Snyder's *Watchmen*." *Cinema Journal* 56.2 (2017): 125–131.

Wandtke, Terrence R., ed. *The Amazing Transforming Superhero! Essays on the Revision of Characters in Comic Books, Film and Television*. Jefferson, NC: McFarland, 2007.

Whelehan, Imelda. *Adaptations: From Text to Screen, Screen to Text*. New York: Routledge, 1999.

Yockey, Matt, ed. *Make Ours Marvel: Media Convergence and a Comics Universe*. Austin: U of Texas P, 2017.

WORKS CITED

Altman, Rick. "Reusable Packaging: Generic Products and the Recycling Process." *Refiguring American Film Genre: Theory and History*. Ed. Nick Browne. Berkeley: U of California P, 1998. 1–41.

Berenson, Tessa. "Here's What Donald Trump Says Will Happen If He Loses on Tuesday." *Time* 7 Nov. 2016. http://time.com/4560707/donald-trump-election-loss-rigged/.

Berlatsky, Noah. "Superheroes Aren't Modern Myths (They're Melodramas)." *Random Nerds* 24 May 2016. http://randomnerds.com/superheroes-arent-modern-myths-theyre-melodramas/.

Bolter, Jay, and Richard Grusin. *Remediation: Understanding New Media*. Cambridge, MA: MIT P, 2000.

Bordwell, David, and Kristin Thompson. *Minding Movies: Observations on the Art, Craft, and Business of Filmmaking*. Chicago: U of Chicago P, 2011.

Brooker, Will. *Batman Unmasked: Analyzing a Cultural Icon*. New York: Continuum, 2001.

"Bryan Singer: I Identified with the X-Men Because I'm Gay." *Channel 24* 21 Apr. 2016. http://www.channel24.co.za/Movies/News/bryan-singer-i-identified-with-the-x-men-because-im-gay-20160421.

Bukatman, Scott. *Matters of Gravity: Special Effects and Supermen in the 20th Century.* Durham, NC: Duke UP, 2003.

———. "Why I Hate Superhero Movies." *Cinema Journal* 50.3 (Spring 2011): 118–122.

Burke, Liam. *The Comic Book Film Adaptation: Exploring Modern Hollywood's Leading Genre.* Jackson: U of Mississippi P, 2015.

Campbell, Joseph. *The Hero's Journey: Joseph Campbell on his Life and Work.* Novato, CA: New World Library, 1990.

"Catwoman Movie Mauled by Critics." *BBC Newsround* 23 July 2004. http://news.bbc.co.uk/cbbcnews/hi/tv_film/newsid_3919000/3919521.stm.

Ceiply, Michael. "New Year, Old Story: Gun Violence Still Rising in PG-13 Films, Report Says." *Deadline Hollywood* 11 Jan. 2017. http://deadline.com/2017/01/gun-violence-is-still-rising-in-pg-13-films-pediatrics-journal-says-1201882066/.

Chang, K. C. *Art, Myth, and Ritual: The Path to Political Authority in Ancient China.* Cambridge, MA: Harvard UP, 1983.

Cohen, Michael. "Dick Tracy: In Pursuit of a Comic Book Aesthetic." *Film and Comic Books.* Ed. Ian Gordon, Mark Jancovich, Matthew P. McCallister. Jackson: U of Mississippi P, 2010. 13–36.

Costello, Matthew J. *Secret Identity Crisis: Comic Books and the Unmasking of Cold War America.* New York: Continuum, 2009.

Danesi, Marcel. *Encyclopedic Dictionary of Semiotics, Media and Communication.* Toronto: U of Toronto P, 2000.

Dargis, Manohla, "Dark Was the Young Knight Battling His Inner Demons." *New York Times* 15 June 2005. http://www.nytimes.com/2005/06/15/movies/dark-was-the-young-knight-battling-his-inner-demons.html?_r=0.

———. "Taming a Demon." *Los Angeles Times* 20 June 2003. http://articles.latimes.com/2003/jun/20/entertainment/et-dargis20.

Davis, Blair. *Movie Comics: Page to Screen/Screen to Page.* New Brunswick, NJ: Rutgers UP, 2017.

Dubrow, Heather. *Genre.* London: Methuen, 1982.

Durkheim, Émile. "The Dualism of Human Nature and Its Social Conditions." *Durkheimian Studies* 11 (2005): 35–45.

Eisner, Will, and Frank Miller. *Eisner/Miller: A One-on-One Interview.* Milwaukie, OR: Dark Horse Comics, 2005.

Fawaz, Ramzi. *The New Mutants: Superheroes and the Radical Imagination of American Comics.* New York: NYU P, 2016.

Federman, Mark. "The Fifth Law of Media." Mark Federman's website n.d. http://individual.utoronto.ca/mark federman/FifthLawofMedia.pdf.

Flanagan, Martin. "Teen Trajectories in Spider-Man and Ghost World." *Film and Comic Books.* Ed. Ian Gordon, Mark Jancovich, Matthew P. McCallister. Jackson: U of Mississippi P, 2010. 137–159.

Gaiman, Neil. *Norse Mythology.* New York: Norton, 2017.

Galloway, John T., Jr. *The Gospel According to Superman.* Philadelphia: A. J. Holman, 1973.

Gibson, Mel. "'Wham! Bam! The X-Men Are Here': The British Broadsheet Press and the X-Men Films and Comic." *Film and Comic Books.* Ed. Ian Gordon, Mark

Jancovich, Matthew P. McCallister. Jackson: U of Missis-
sippi P, 2010. 101–115.

Gordon, Ian. *Superman: The Persistence of an American Icon*.
New Brunswick, NJ: Rutgers UP, 2017.

Grant, Barry Keith. *Film Genre: From Iconology to Ideology*.
London: Wallflower, 2007.

Grodal, Torben. *Moving Pictures: A New Theory of Film
Genres, Feelings, and Cognition*. New York: Oxford UP,
1997.

Herviou, Nicole. "Superhero Comics Creators: We're
Political, and Always Have Been." *Mashable* 16 Mar. 2017.
http://mashable.com/2017/03/16/politics-in-comics/
#ALlihbO2_SqI.

Higgens, Scott. *Matinee Melodrama: Playing with Formula in
the Sound Serial*. New Brunswick, NJ: Rutgers UP, 2015.

Holifield, E. Brooks. "Why Are Americans So Religious?
The Limitations of Market Explanations." *Religion and
the Marketplace in the United States*. Ed. Jan Steivermann,
Philip Goff, and Detlef Junker. Oxford: Oxford UP, 2015.
33–59.

Jeffries, Dru. *Comic Book Film Style: Cinema at 24 Panels per
Second*. Austin: U of Texas P, 2017.

Johns, Geoff, and David Finch, *Forever Evil*. New York: DC
Comics, 2013.

Johnson, Derek. *Media Franchising: Creative License and
Collaboration in the Culture Industries*. New York: NYU
P, 2013.

Keck, William. "Rebecca Is Quiet at 'Punisher' Premiere."
USA Today 13 Apr. 2004. http://usatoday30.usatoday
.com/life/people/2004-04-13-punisher-premiere_x.htm.

Keegan, Rebecca. *The Futurist: The Life and Films of James Cameron.* New York: Three Rivers, 2010.

Kit, Borys. "Hasbro Cinematic Universe Takes Shape with Michael Chabon, Brian K. Vaughan, Akiva Goldsman." *Hollywood Reporter* 21 Apr. 2016. http://www.hollywoodreporter.com/heat-vision/hasbro-cinematic-universe-takes-shape-886316.

Knowles, Chris. *Our Gods Wear Spandex: The Secret History of Comic Book Heroes.* Newberryport, MA: Weiser Books, 2007.

LaSalle, Mick. "Being Spider-Man Is No Easy Job. But the New Film Is Seamless." *San Francisco Gate* 29 June 2004. http://www.sfgate.com/movies/article/Being-Spider-Man-is-no-easy-job-But-the-new-film-2710973.php.

Levitz, Paul. *The Golden Age of DC Comics.* Los Angeles: Taschen, 2012.

Liptak, Jeff, Jeff Zeleny, Sara Murray, and Jim Acosta. "Inside an Embattled Trump's Most Consequential Evening of Turmoil Yet." *CNN* 18 May 2017. http://www.cnn.com/2017/05/17/politics/trump-mueller-white-house-turmoil/index.html.

McAllister, Matthew, Edward H. Sewell Jr., and Ian Gordon. "Introducing Comics and Ideology." *Comics and Ideology.* Ed. McAllister, Sewell, and Gordon. New York: Peter Lang, 2001. 1–14.

McCarthy, Todd. "Review: Doctor Strange." *Hollywood Reporter* 23 Oct. 2016. http://www.hollywoodreporter.com/review/doctor-strange-review-940709.

McLuhan, Marshall. *Understanding Media: The Extensions of Man.* New York: McGraw-Hill, 1964.

Morrison, Grant. *Supergods*. New York: Spiegel and Grau, 2011.

Morton, Drew. *Panel to the Screen: Style, American Film, and Comic Books during the Blockbuster Era*. Jackson: U of Mississippi P, 2016.

Neale, Sam. *Genre and Hollywood*. New York: Routledge, 2000.

Nyberg, Amy Kiste. *Seal of Approval: The History of the Comics Code*. Jackson: U of Mississippi P, 1998.

O'Brien, Harvey. *Action Movies: The Cinema of Striking Back*. New York: Wallflower, 2012.

Otto, Jeff. "David Goyer Talks Batman, Iron Man, Comics and More." *IGN* 27 Feb. 2004. http://www.ign.com/articles/2004/02/27/david-s-goyer-talks-batman-iron-man-comics-and-more.

Owen, James. "Second Hand Thrills: Bigger Isn't Better in 'Guardians' Sequel." *Columbia Daily Tribune* 4 May 2017. http://www.columbiatribune.com/entertainment/20170504/second-hand-thrills-bigger-isnt-better-in-guardians-sequel/1.

Reynolds, Richard. *Superheroes: A Modern Mythology*. Jackson: U of Mississippi P, 1994.

Rossen, Jake. *Superman vs. Hollywood*. Chicago: Chicago Review P, 2008.

Sargent, Greg. "Trump's Ugly and Dishonest New TV Ad Shows He Isn't Changing a Thing." *Washington Post* 19 Aug. 2016. https://www.washingtonpost.com/blogs/plum-line/wp/2016/08/19/trumps-ugly-and-dishonest-new-tv-ad-shows-he-isnt-changing-a-thing/.

Scott, Kevin Michael, ed. *Marvel Comics' Civil War and the Age of Terror.* Jefferson, NC: McFarland, 2015.

Spencer, Nick, and Daniel Acuna. *Secret Empire.* New York: Marvel Comics, 2017.

Steinberg, Brian. "'Avengers' Beat Doctor Doom, but Can They Conquer Fickle Movie Public?" *Advertising Age* 4 Oct. 2010. http://adage.com/article/madisonvine -news/movie-marketing-marvels-avengers-conquer -public/146245/.

Stevenson, Peter W. "This Section of Trump's Inaugural Address Sounds a Lot like Bane from 'Batman.'" *Washington Post* 20 Jan. 2017. https://www.washingtonpost .com/news/the-fix/wp/2017/01/20/this-section-of -trumps-inaugural-address-sounds-a-lot-like-bane-from -batman/?utm_term=.34ff2ce66f08.

"Warden, White, Van Duren Establish New Hollywood Literary Agency." *Variety* 25 June 1990.

Watkins, Eli. "Charlottesville Mayor on Trump: 'Look at the Campaign He Ran.'" *CNN* 13 Aug. 2017. http://www .cnn.com/2017/08/13/politics/charlottesville-mayor -michael-signer-cnntv/index.html.

Wertham, Fredric. *Seduction of the Innocent.* New York: Rinehart, 1954.

Wilde, Oscar. *The Decay of Lying: A Dialogue.* London: Kegan Paul, Trench, 1889.

Yockey, Matt. *Batman.* Detroit: Wayne State UP, 2014.

FILMS CITED

Addams Family, The (1991)

Addams Family Values (1993)

Adventures of Captain Marvel (1941)

Amazing Spider-Man, The (2012)

Amazing Spider-Man 2, The (2014)

American Splendor (2003)

Ant-Man (2015)

Aquaman (2018)

Art School Confidential (2006)

Atom Man vs. Superman (1950)

Avengers, The (2012)

Avengers: Age of Ultron (2015)

Avengers: Infinity War (2018)

Batman (1989)

Batman Returns (1992)

Batman Forever (1995)

Batman and Robin (1997)

Batman Begins (2005)

Batman v. Superman: Dawn of Justice (2016)

Blackhawk (1952)

Blade (1998)

Blade II (2002)

Blade: Trinity (2004)

Bulletproof Monk (2003)

Captain America (1944)

Captain America (1990)

Captain America: The First Avenger (2011)

Captain America: The Winter Soldier (2014)

Captain America: Civil War (2016)

Captain Marvel (2019)

Casper (1995)

Catwoman (2004)

Constantine (2005)

Cowboys and Aliens (2011)

Creepshow (1982)

Creepshow 2 (1987)

Crow, The (1994)

Daredevil (2003)

Dark Knight, The (2008)

Dark Knight Rises, The (2012)

Deadpool (2016)

Dennis the Menace (1993)

Dick Tracy (1990)

Doctor Strange (2016)

Dredd (2012)

Elektra (2005)

Fantastic Four, The (1994)

Fantastic Four (2005)

Fantastic Four: Rise of the Silver Surfer (2007)

Fantastic Four (2015)

Fritz the Cat (1972)

From Hell (2001)

Ghost Rider (2007)

Ghost Rider: Spirit of Vengeance (2012)
Ghost World (2001)
Green Lantern (2011)
Guardians of the Galaxy (2014)
Guardians of the Galaxy Vol. 2 (2017)
Hellboy (2004)
Hellboy II: The Golden Army (2008)
History of Violence, A (2005)
Howard the Duck (1986)
Hulk (2003)
Incredible Hulk, The (2008)
Iron Man (2008)
Iron Man 2 (2010)
Iron Man 3 (2013)
Japoteurs (1942)
Judge Dredd (1995)
Justice League (2017)
Kick-Ass (2010)
Kingsman: The Secret Service (2015)
League of Extraordinary Gentlemen, The (2003)
Logan (2017)
Losers, The (2010)
Man of Steel (2013)
Mask, The (1994)
Men in Black (1997)
Mystery Men (1999)
Nine Lives of Fritz the Cat (1974)
Persepolis (2007)
Punisher, The (1989)
Punisher, The (2004)

RED (2010)
Richie Rich (1994)
Road to Perdition (2002)
Rocketeer, The (1991)
Scott Pilgrim vs. the World (2010)
Sin City (2005)
Sin City: A Dame to Kill For (2014)
Spawn (1997)
Spider-Man (2002)
Spider-Man 2 (2004)
Spider-Man: Homecoming (2017)
Spirit, The (2008)
Spy Smasher (1942)
Steel (1997)
Suicide Squad (2016)
Supergirl (1984)
Superman (1941)
Superman (1948)
Superman and the Mole Men (1952)
Superman (1978)
Superman II (1980)
Superman III (1983)
Superman IV: The Quest for Peace (1987)
Superman Returns (2006)
Swamp Thing (1982)
Tales from the Crypt (1972)
Tales from the Crypt: Demon Knight (1995)
Tales from the Crypt: Bordello of Blood (1996)
Tales from the Crypt: Ritual (2002)
Tank Girl (1995)

Teenage Mutant Ninja Turtles (1990)
Teenage Mutant Ninja Turtles II: The Secret of the Ooze (1991)
Teenage Mutant Ninja Turtles III (1993)
30 Days of Night (2007)
Thor (2011)
Thor: The Dark World (2013)
Thor: Ragnarok (2017)
300 (2007)
300: Rise of an Empire (2014)
Timecop (1994)
Vault of Horror, The (1973)
V for Vendetta (2005)
Wanted (2008)
Watchmen (2009)
Wilson (2017)
Wonder Woman (2017)
X-Men (2000)
X2: X-Men United (2003)
X-Men Origins: Wolverine (2009)
X-Men: First Class (2011)
X-Men: Days of Future Past (2014)
X-Men: Apocalypse (2016)

INDEX

ABOUT THE AUTHOR

Blair Davis is an associate professor of media and cinema studies in the College of Communication at DePaul University in Chicago. His books include *Movie Comics: Page to Screen / Screen to Page* (2017) and *The Battle for the Bs: 1950s Hollywood and the Rebirth of Low-Budget Cinema* (2012). He is currently on the executive board of the Comics Studies Society and has chaired the Comics Studies scholarly interest group for the Society for Cinema and Media Studies since 2012.